puppy
life

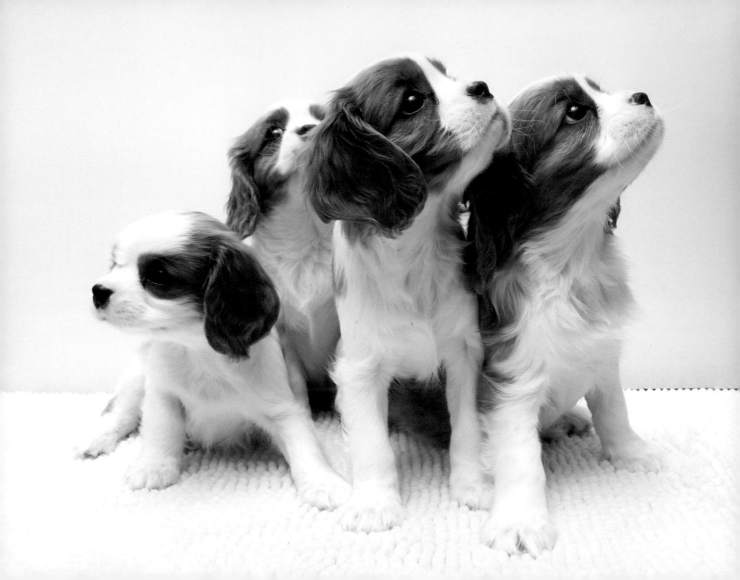

puppy life

The First Eight Weeks of Bonding, Playing, and Growing

Traer Scott

PRINCETON ARCHITECTURAL PRESS · NEW YORK

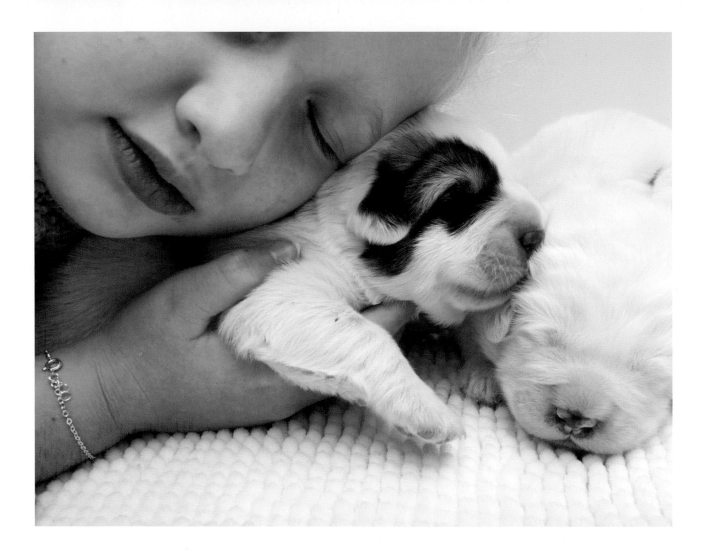

For Agatha, my human puppy
and favorite being on the planet

Contents

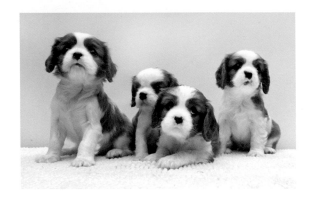

Cavalier King Charles Spaniels
12

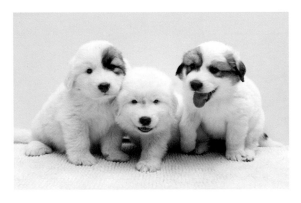

Great Pyrenees
66

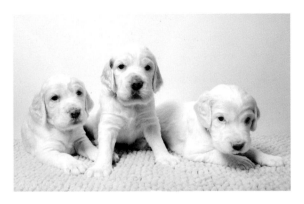

English Setters

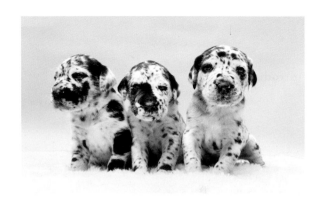

Daniffs

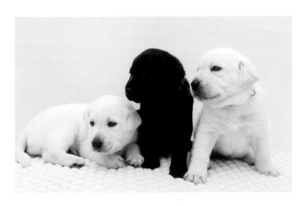

Labrador Retrievers

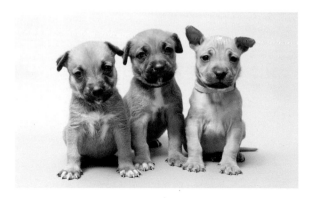

Mixed Breed

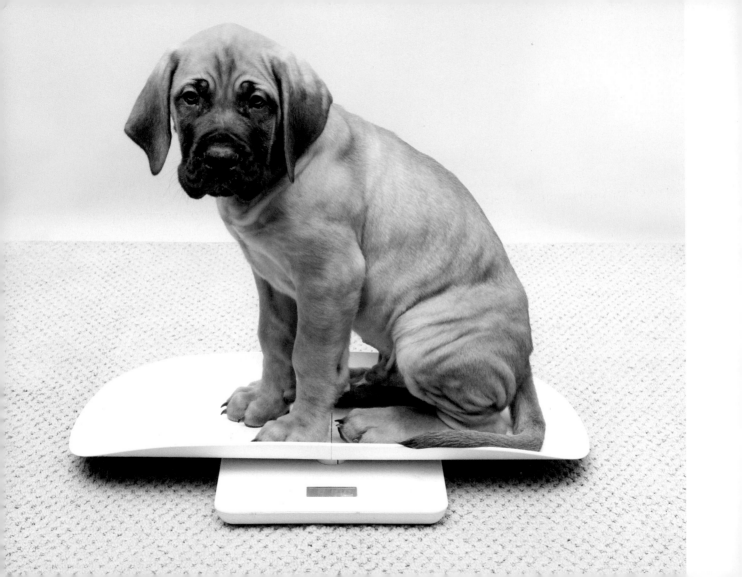

Introduction

Photographing almost nothing but puppies for six months is like chasing the sun and never seeing it set. An endless parade of new life, one litter after another brought into the world through the labor of the mothers and their infallible instincts, surrounded by fretting, excited humans who make sure the newborn pups get enough milk, enough warmth, and, eventually, enough love.

Watching these tiny souls grow and develop into dogs over eight weeks is nothing short of miraculous. Born with their eyes and ears sealed, puppies move through developmental stages at lightning speed: every week there is a new milestone. *Puppy Life* celebrates each week's changes and achievements while comparing growth among breeds that vary vastly in size and shape as well as purpose.

The largest puppy in the Cavalier King Charles spaniel litter was six ounces at birth, while the biggest of the Great Dane puppies was one pound, fourteen ounces—making it five times bigger. Despite mammoth disparities in birth weight, most puppies open their eyes somewhere around week two, by six weeks are no longer nursing, and by eight weeks are old enough to go to their new homes. However, size does play a role in exactly *when* a puppy goes home. Smaller breeds tend to go home anytime between eight and twelve weeks, while large breeds almost always go home at eight weeks. This is not due to developmental differences— just size. Smaller dogs have smaller litters and smaller puppies; larger dogs who are biologically able to safely carry more pups have bigger litters and bigger puppies.

A litter of nine rambunctious Labradors who weigh fifteen pounds each at eight weeks are much harder to house and clean up after than a litter of four snuggly Cavaliers who weigh five pounds each.

While I shoot puppies I generally lie on my stomach, with the puppies running everywhere—climbing on my back, biting my leggings, yanking on my ponytail, eating the backdrop, pooping on the backdrop. (One time a puppy actually pulled a chunk of hair out of my head.) It's total chaos, and I guess because I don't scream and run out of the room or start sobbing, at some point during almost every shoot I inevitably hear "You are so patient! How do you have the patience to do this?"

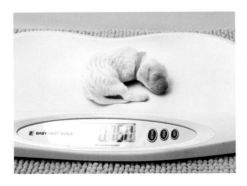

But I am not patient—not at all. The only two things I have patience for are my daughter and animals, which, probably not coincidentally, are two things that I love immensely and unconditionally. I also *have* to be patient because if I give up, I don't get the shot. And I want, or more accurately *need*, to get the shot. If you wait long enough, eventually even puppies get tired.

Though I have photographed puppies for more than ten years, there were some new surprises in making *Puppy Life*. One was watching my own baby, with whom I was pregnant when I made my first puppy book, turn into an expert photo assistant at age ten. *Puppy Life* was made primarily in the summer, and as such, my daughter was with me on almost every shoot. When she was little, she always hung back at photo shoots or just played with the animals, so this time around I was amazed by how hands-on she was. Within a few weeks she was working hard: lugging and setting up equipment, hauling two or three puppies at a time up and down stairs and wrangling them back onto the backdrop over and over and over again. Wrangling is much

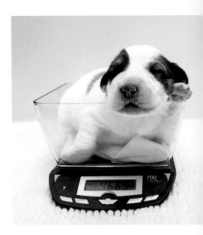

harder work than it appears, and we were both usually drenched in sweat by the end. Like me, she is not patient by nature, but you would never know that from watching her work with puppies.

I was also pleasantly surprised by how few expectant mamas we now have in shelters and rescues in New England. I wanted to include at least one mixed-breed shelter litter, but that proved more difficult than I anticipated because adoption and spay/neuter campaigns have been so effective that pregnant moms are virtually unheard of now unless they are transports. Likewise, the vast majority of puppies available for adoption in the Northeast are transported up from the South, where, sadly, there are still countless unwanted litters.

Puppies are always bittersweet to me. I revel in their newness, their tiny paw pads, their pink little tongues and miniature tails that start to wag almost at birth, but I also envision them grown up and hope they will be loved and cared for once they stop being small and cute. A puppy is a massive responsibility, and raising one takes immense patience and consistency.

Much like teenagers, adolescent puppies act out and test boundaries and, like teens, are almost full-grown in size, so that infant adorability that renders so much forgivable is gone. That is the age when dogs are often surrendered to shelters and rescues because, simply put, they are a LOT. I estimate that every time I raise a puppy I lose about 15 percent of my possessions to chewing, shredding, and other destructive behavior. Why can't we have nice things? I wonder to myself as I scrape hair off the couch, vacuum up the shredded toilet paper for the third time in one day, and put all of the books with chewed corners just one shelf higher, and then I remember—oh, right: dogs! But I wouldn't have it any other way. 🐾

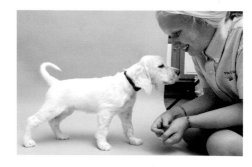

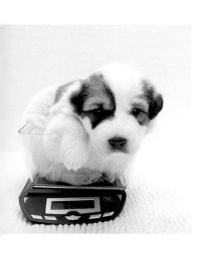

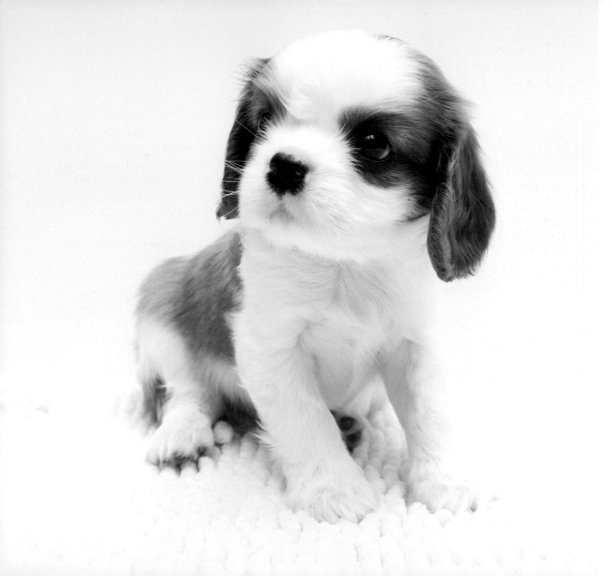

Cavalier King Charles Spaniels

Cavalier King Charles spaniels, casually known as "Cavs," are one of the most popular pure breeds in America. Cavs are known for being gentle and loving as well as athletic, a rare combination in a toy breed. These tiny spaniels usually weigh between thirteen and eighteen pounds full-grown.

In small litters there is usually not a runt, but in this case, the only male puppy was born much smaller than the three girls. Weighing only 2.5 ounces, the puppy, who was quickly dubbed Mighty, was barely more than a third of the birth size of the largest pup, who was 6.1 ounces.

From the very beginning, Mighty appeared to be strong and healthy despite being tiny. The breeder, who is also a farmer, has raised countless generations of goats and other livestock, as well as dogs, and was ready to bottle feed him, but it never was necessary. We all wondered: Would Mighty catch up with his sisters as he grew or always be small? 🐾

1

Warm and safe! The first week of life for puppies is all about adjusting to the world outside of the womb. Staying warm and fed are the main priorities. Dogs are born with their eyes and ears sealed, so they use their keen sense of smell to find the right spot to nurse. Newborn puppies usually need to eat every three to four hours, and they spend the rest of their time sleeping. A puppy's weight often doubles in the first week. Adult Cavaliers have coal-black noses, but they are born with pink noses. The pigment will come in over the next eight weeks.

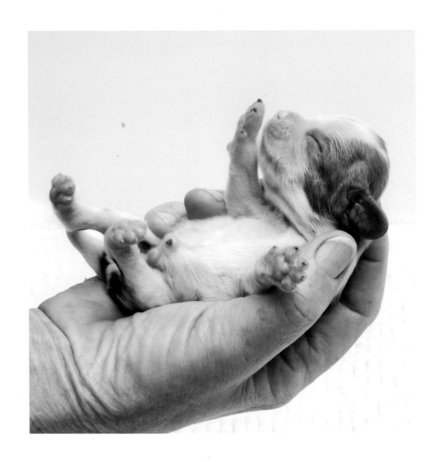

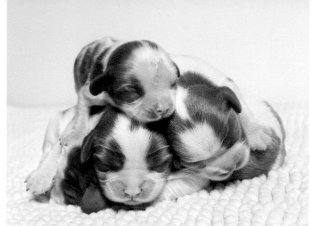

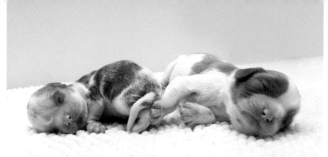

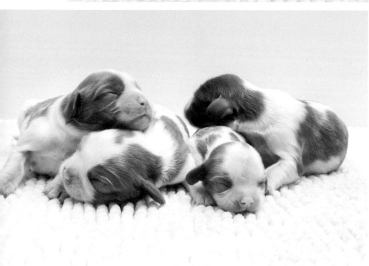

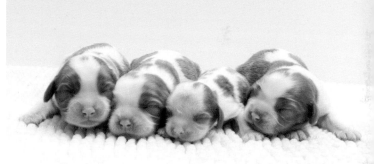

Puppy piles are adorable, but they also help keep newborn pups comfortable. Dogs are pack animals and instinctively want to be near other dogs from birth. Piling up helps newborn puppies bond with each other while the scent, gentle breathing, and body heat of their siblings help keep them calm and warm.

WEEK

2

Growing and sleeping! The Cavs are now double the size they were at birth, with round, full bellies. Though the eyes of some pups are showing early signs of opening, they are still closed, so the puppies continue to navigate by smell and feel. They have begun to move around a little bit by crawling on their stomachs, and their first teeth have started coming in. The Cavs are still nursing up to eight times a day and sleeping almost constantly.

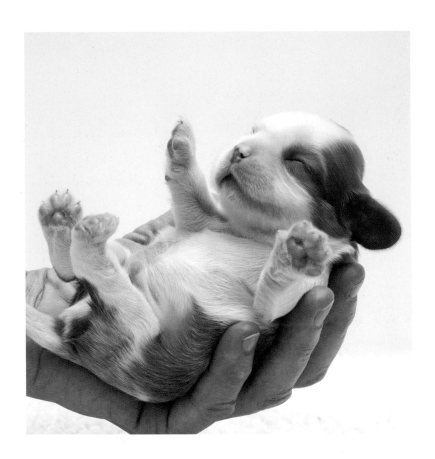

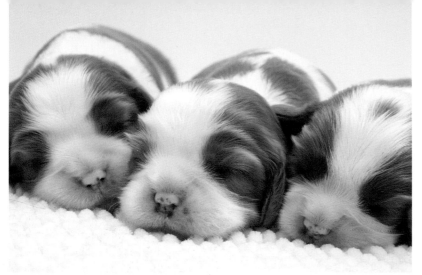

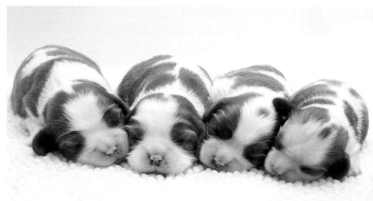

Little black spots have started coming in on their noses!
These will fill in more and more each week.

3

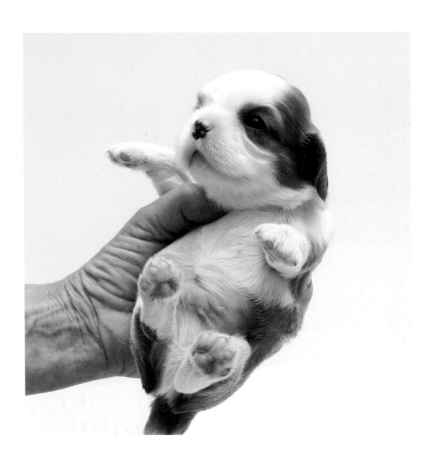

The puppies' eyes and ears have finally opened, and they are seeing and hearing the world for the first time! They begin interacting with people, and their relationship with siblings becomes more engaged. The pups can also sit up and toddle around now.

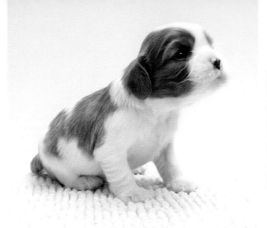

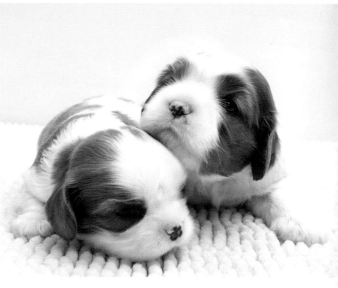

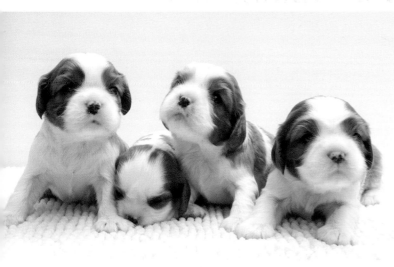

Mighty continues to thrive, though he is still proportionately tiny and a little bit less active than his sisters.

4

Barking, growling, and playing! These little puppies have found their voice and have really started acting like dogs! Though still a bit wobbly, they are now much better at walking and have begun to climb out of their whelping box and explore the house. They have also started to play with their siblings and meet family members. Mighty remains smaller but has caught up developmentally.

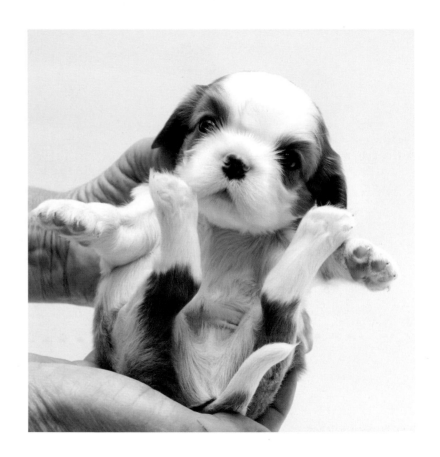

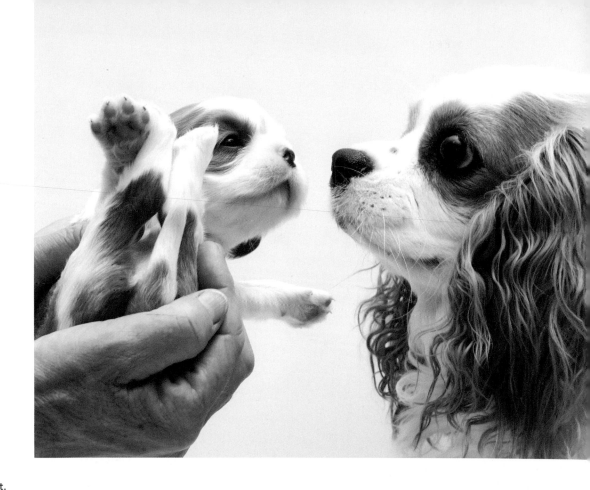

Mighty meets his aunt.

5

Off and running! The Cavalier puppies can walk and run now, and they do so as often as they can. They have begun wagging their tails in play and when they see people. As a first step toward weaning off mother's milk, the pups have begun eating a mush of dog food mixed with milk. They still nurse, but now it's only about two to three times a day.

They acknowledge and engage with people much more and woof when they want someone's attention!

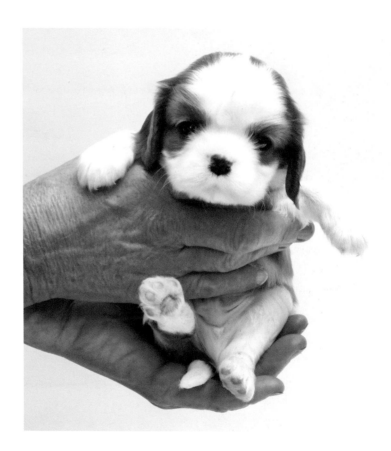

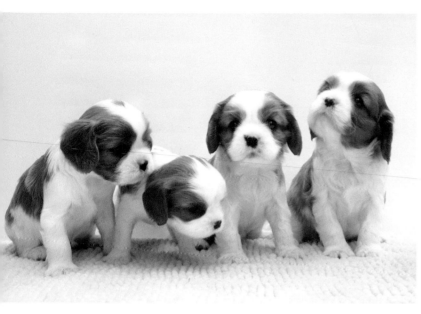

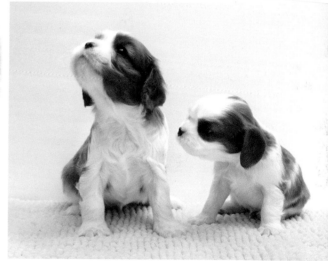

The puppies are strong on their legs now!

6

Jumping for joy! The puppies are becoming more and more active each week. Now they are jumping and leaping in play! They have moved out of the whelping box and into a pen with newspapers on the floor, which they love to shred! They now get to spend some of the day outside in the grass near the other animals on the farm. Goats, chickens, and pigs are all near the puppy pen, so the pups have a lot of new noises and sights to occupy them. They are also meeting lots of different adults and children to help them be well socialized.

The Cavs' different personalities are beginning to show. One of the girls is quiet and loves being cuddled, another is active and social, the third is sweet and calm. Mighty, still noticeably smaller, is completely fearless and has become the boldest of the litter!

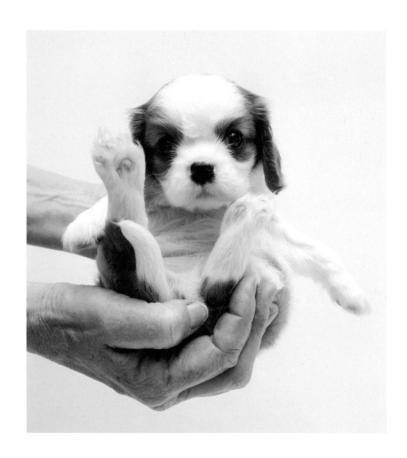

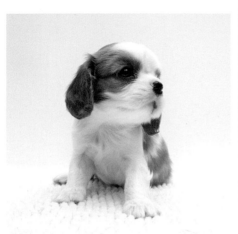

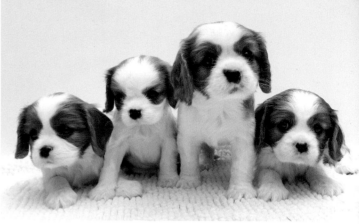

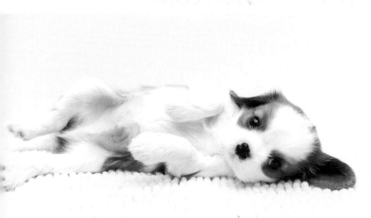

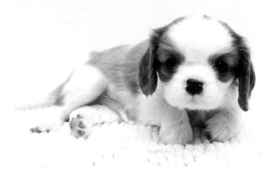

The Cavaliers' noses are almost completely
black now but still have some pink areas left.

7

Rough and tumble! Play has become much rowdier, and the puppies are now nibbling on people's hands and chasing their feet as they walk. On warm days they spend all day outside in a pen and come inside to sleep. Mighty has become bolder and bolder each week and now plays the roughest of any of the puppies. Though he will always be smaller than his sisters, he bosses them around any chance he gets. Mighty is also the most vocal, barking and growling and charging at anything in his path! He has definitely turned out to be "small but mighty," just as his name predicted.

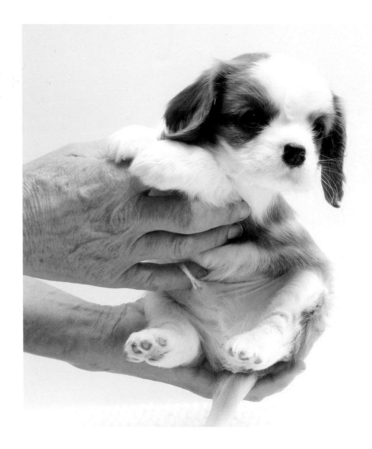

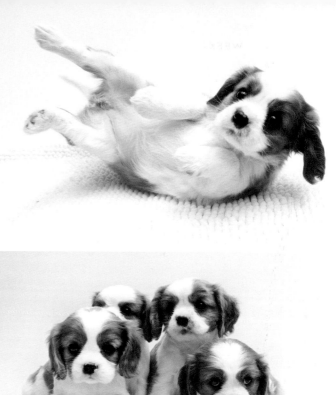

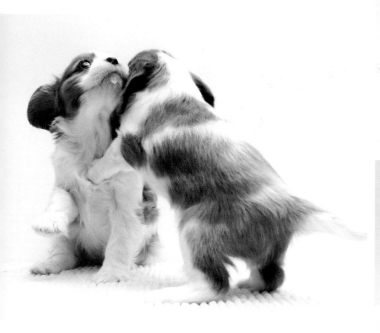

The pups like roughhousing with each other.
They growl and bark and roll around in play.

8

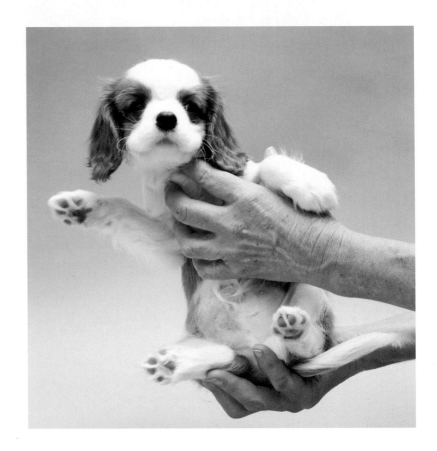

All grown up! Mostly. The Cavaliers are now fully independent from their mother, and although they still live in the same house, they are fully weaned. All of their teeth have come in, and they are eating regular dog food three times a day. This is the week when they will have their first vet visit. The puppies are technically old enough to go to their new homes, but because they are a toy breed, they are still very small. Mighty weighs only three pounds, while his biggest sister weighs almost five. The Cavaliers will stay at the farm for a few more weeks to have more time with Mom and each other, which will strengthen their social development.

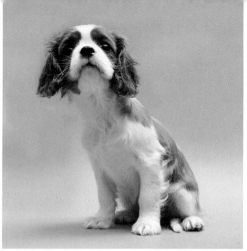

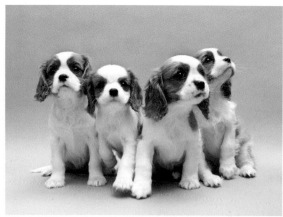

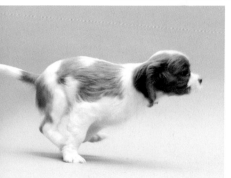

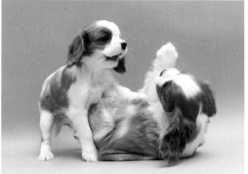

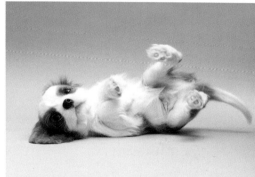

The Cavs are full of energy now, speeding around the house and shredding, tugging on, or tearing anything they can get their teeth on.

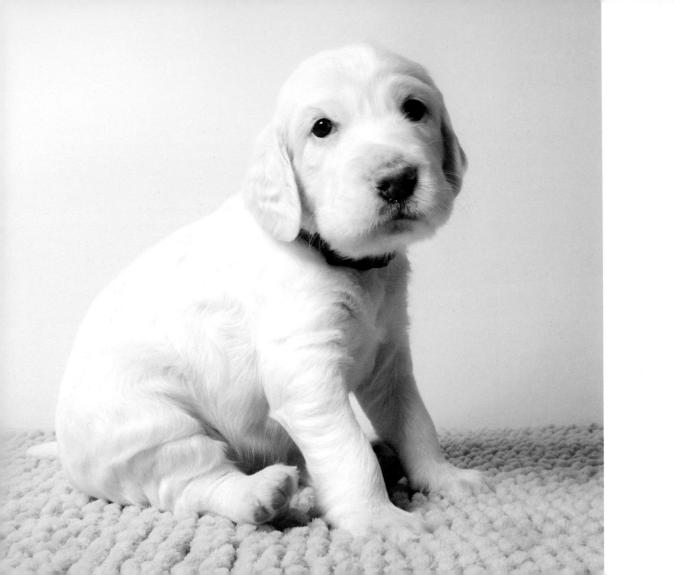

English Setters

English setters are gentle, friendly, medium-size dogs who adore children. Setters are gun dogs, which are a type of hunting dog developed to help hunters find game. Traditionally they were trained to follow the scent of game birds with their heads held high; when they detected the birds, the dogs would crouch down, or "set," to alert the hunter. These days, most English setters are companions. These high-energy dogs weigh between fifty and seventy-five pounds full-grown.

This litter of eight was made up of four boys and four girls. Each puppy was given a colorful collar soon after birth to help the family tell them apart. The mother and daughter in this family run a grooming business together. They also show their setters in dog shows every month as breeder/owner/handlers, which means they bred the dog they're showing, own the dog, and do the actual handling during the judging of the show. 🐾

WEEK

1

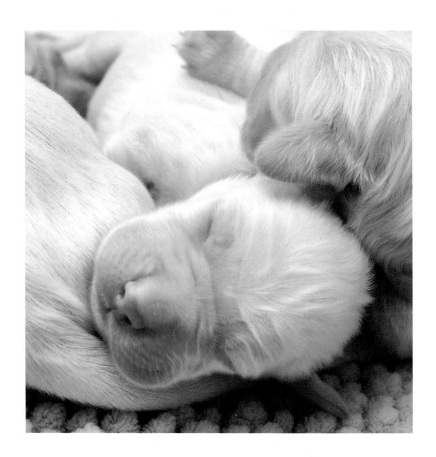

Cozy and pink! These pups were born in July, so it wasn't a struggle to keep them warm, but since newborns cannot regulate their own body temperature, they like to pile up and enjoy the comfort and warmth of their siblings. Though the puppies' coats will develop reddish "ticking," or spots, as they grow, they are born solid white with pink ears and snouts.

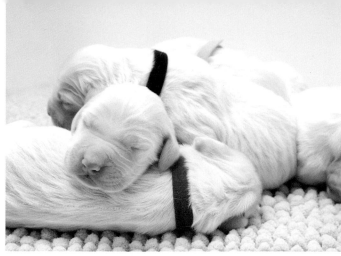

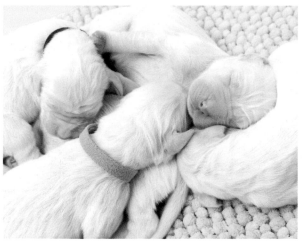

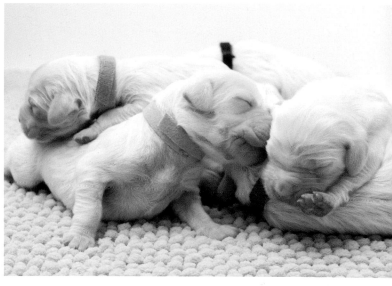

The shape of the newborn setter's nose gives a hint that this will be a dog with a long snout. Compare the nose of the setter with that of the short-snouted Cavalier and you will see a difference!

2

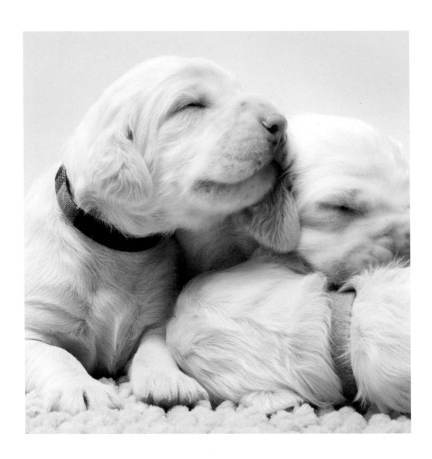

Life is sweet and sleepy! The puppies' eyes are still closed, but they are now able to raise their heads and crawl around a bit. They still need to be next to Mom or each other most of the day in order to stay warm. Like all newborns, they are nursing every three or four hours and sleeping about twenty-two hours a day!

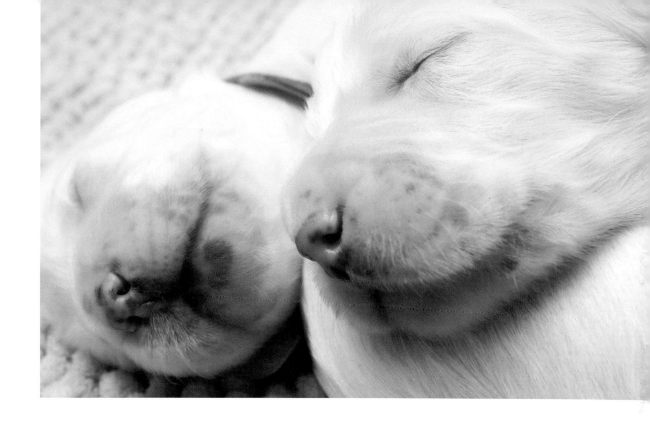

A setter's nose can be either brown or black.
These pups already have brown spots coming in!

3

Aware and social! The puppies' eyes are now open, and they have started to become aware of their surroundings as well as of each other. They are now engaging in very basic play with their siblings, with wagging tails and little growling sounds. They have also started to look out at the world beyond the whelping box, though they can't climb out just yet. Their little noses are already on overdrive, picking up the rich scents of their world, and they have begun to sniff everything.

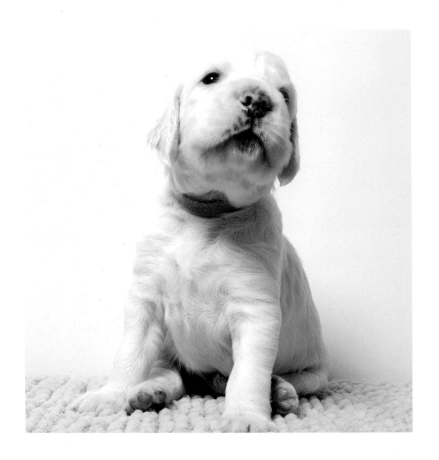

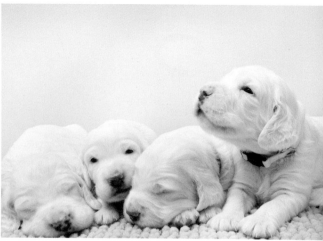

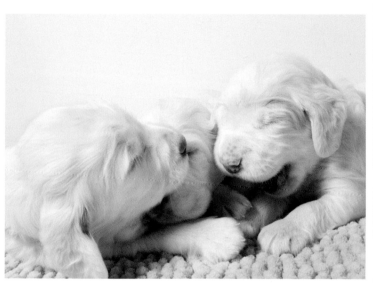

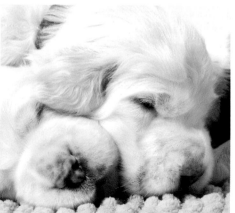

The puppies are still very sleepy and will continue
to sleep twenty to twenty-two hours a day.

4

Exploring independence! Spots have started appearing on the puppies' snouts. Their eyes are beginning to turn from blue to brown, and they have made the first step toward being weaned off mother's milk by licking solid food off their humans' fingers. The pups have also become much more mobile and are now tumbling out of the whelping box on their own. Their interest in people has intensified, and they want to explore the house.

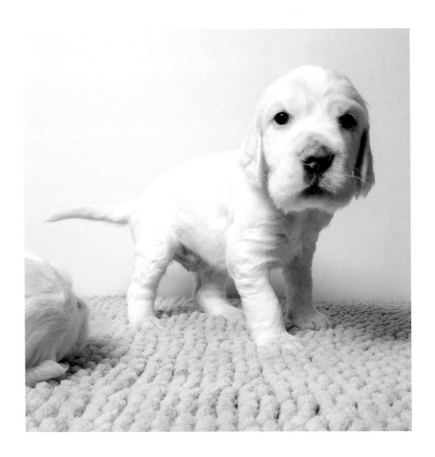

English Setters 38

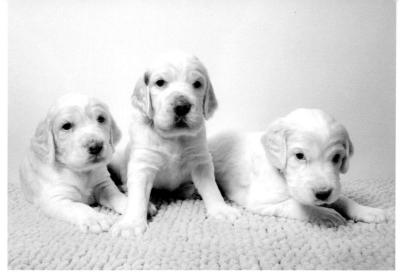

The setter pups are enjoying playing with each other and have started making recognizable gestures like play bows, which invite other dogs to play.

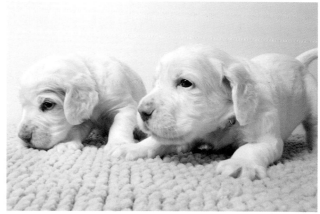

5

A colorful week! The pup's eyes are darkening but still retain a hint of baby blue. More spots have started to come in on their snouts, and we are beginning to see faint ticking coming in on their ears. The setters' snouts are getting more pronounced and elongated with each passing week. Hunting breeds like setters rely heavily on their ability to track scent and therefore have much longer snouts than breeds like the Cavaliers or the mixed-breed litter. The puppies are also eating mush from a bowl and nursing much less; soon they will be fully weaned.

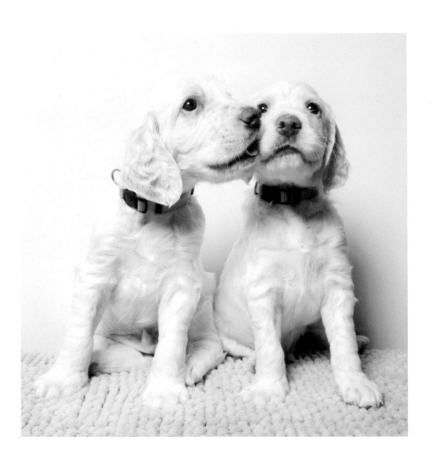

English Setters 40

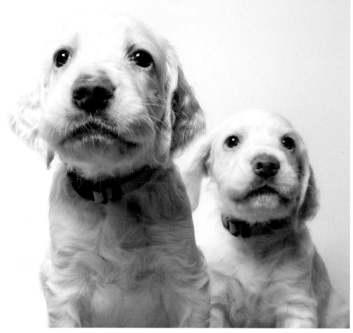

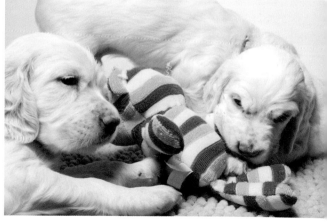

The puppies have discovered toys! In the early weeks, puppies usually have no interest in dog toys, but around week five they usually begin to chew a lot and start to enjoy toys they can gnaw or pull on.

6

A new world of sights and smells! The setter puppies went out into the yard for the first time today and were excited by all the new smells and sights of the world outside the house.

More red ticking is coming in on their bodies and faces as they transition away from solid white coats. They are also starting to learn bite inhibition, which is the ability to control the force of their mouthing. When one of them mouths or bites another puppy in play and it screams, the pup learns to adjust the pressure. This crucial building block in a dog's social skills is necessary to get along with humans and other dogs.

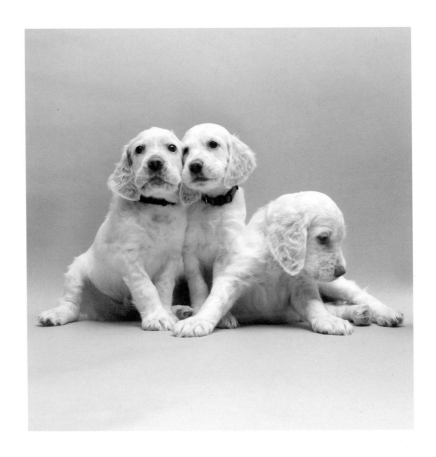

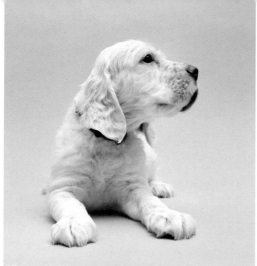

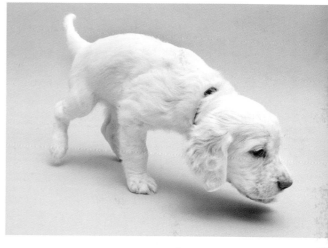

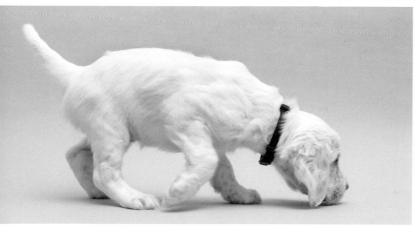

The pups are starting to track, or follow, scents.

7

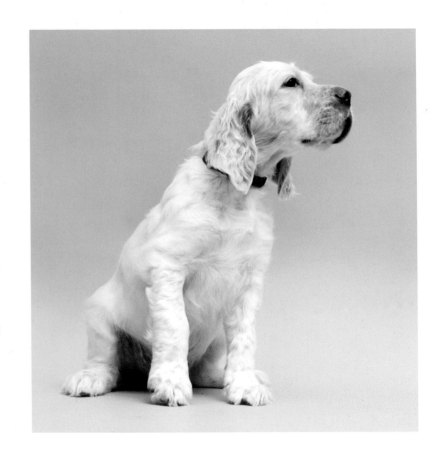

Nose to the ground! This week the puppies have spent much more time playing in the outside pen and in the yard, soaking up the scents. They weigh about ten pounds each now, so they are taking up a lot of space! At seven weeks, puppies can fully regulate their body temperature, so they don't need to keep close to siblings or sleep in a pile anymore, but sometimes they still choose to out of habit and comfort. Their energy level is super high now, and they have started chewing and shredding everything in sight!

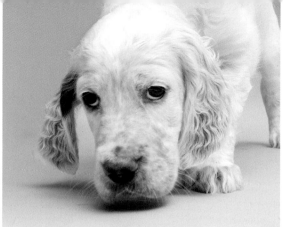

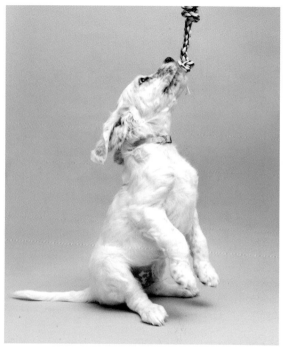

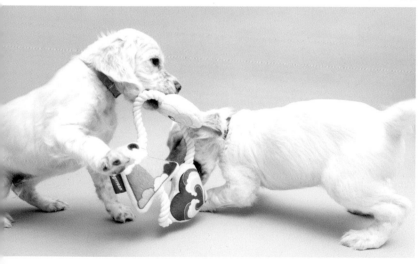

The puppies are starting to really look like the dogs they will become. Their reddish or liver coloring is coming in more each week.

8

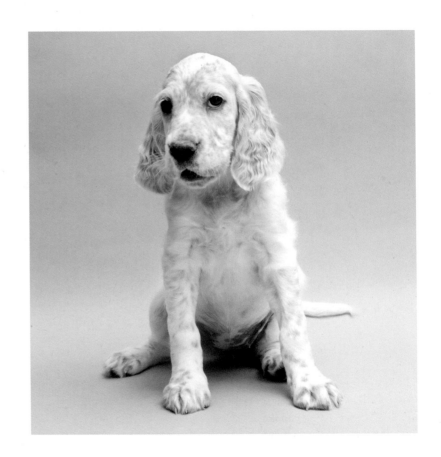

Homestretch! The puppies are now outside most of the time, and their energy level is at an all-time high. They look like proper English setters and weigh about twelve pounds each.

Their forever homes are being chosen, and they will begin leaving to start their new lives next week.

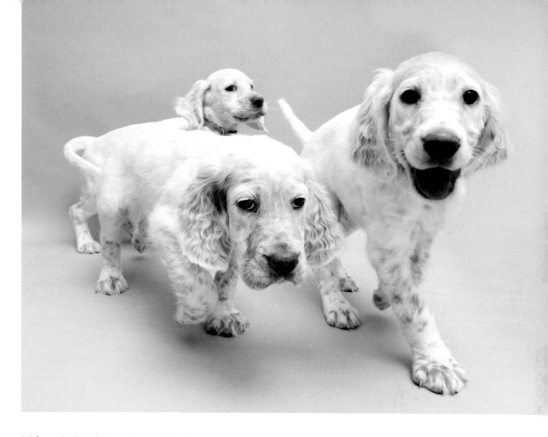

The transition between living a pack life with their littermates and going into a new home without their siblings is always difficult. During their first few days in a new home, puppies usually sleep a lot, cry at night, and need lots of attention, but soon they learn that they are part of a new pack.

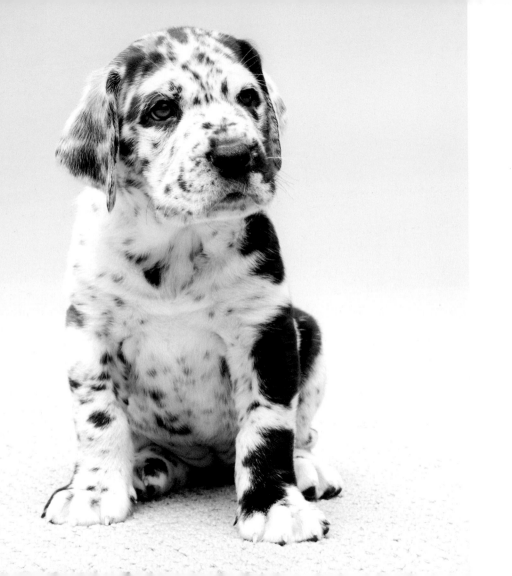

Daniffs

What do you get if you cross two of the largest dog breeds in the world? Giant puppies! A Daniff is a mix between a Great Dane and a mastiff, which are both giant breeds. Mixes like this are designed to soften or enhance certain characteristics of a beloved pure breed, and the Daniff is no exception.

Mastiffs are intelligent, loyal dogs who have been used as guard dogs for centuries and can sometimes be overly protective in daily life. They are also very low-energy dogs and are prone to becoming overweight due to inactivity. Extra weight puts more stress and strain on their joints, which already carry a heavy load; this can cause the dogs a lot of pain or even lameness. Great Danes are more social and energetic than mastiffs but sometimes lack protective instincts.

When you combine the two, you get a beautiful, intelligent, gentle dog who is, ideally, just the right amount of protective while still being playful, loyal, and reasonably energetic for an active family.

Mama Blake is a black Daniff who weighs 160 pounds and is exactly half Great Dane and half English mastiff. Dad Griffin is also a Daniff, weighing 180 pounds, but he is half Great Dane, 26 percent Neapolitan mastiff (think Fang from *Harry Potter*) and 17 percent English mastiff. His coloring is harlequin and brindle, or "brindlequin," which is a white coat with brindle spots and patches. Their ten puppies are extremely colorful, featuring merle, brindle, black, harlequin, fawn, and brindlequin coats. There are eight females and one male. 🐾

1

Big, sleepy puppies! Other than being quite large, the Daniffs are no different from any other newborn puppies. They sleep constantly, waking only to nurse, and stay huddled together for warmth and comfort. Since it is winter, they have a heating pad under the bedding in their whelping box to keep them away from the cold floor. The male is one of two fawn-colored puppies in the litter and is the largest, weighing almost two pounds at birth. Compare this with our smallest breed, the Cavaliers, where the largest pup was only six ounces at birth!

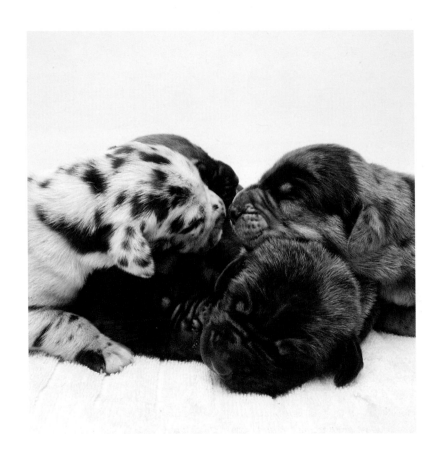

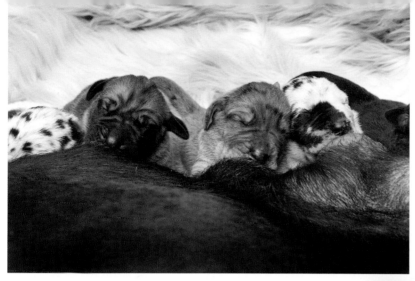

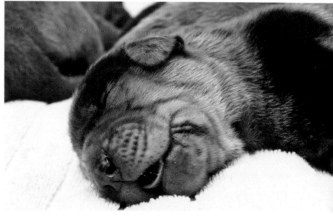

Milk coma! Puppies get very tired after they eat. If you look closely you can still see tiny beads of milk on this pup's mouth. She had just finished nursing and was ready for a nap.

2

Eyes on the prize! The puppies' eyes are starting to open, which is a bit early compared to some of our other litters. Puppies are always a little squinty at first because their focus is still blurry and bright light is overwhelming. They are born with their eyes closed because the retinas are still developing for the first few weeks after birth. Even after they open, it takes several more weeks for the eyes to be completely mature.

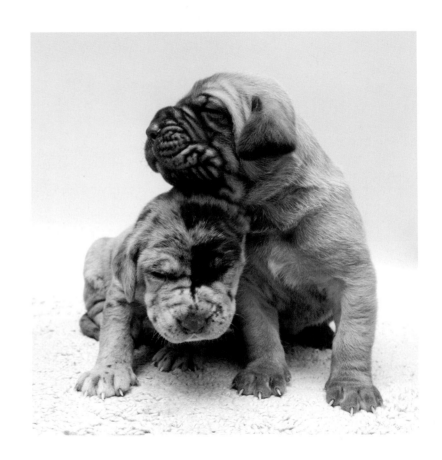

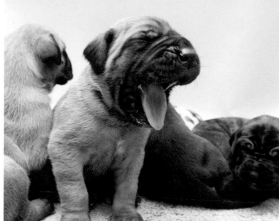

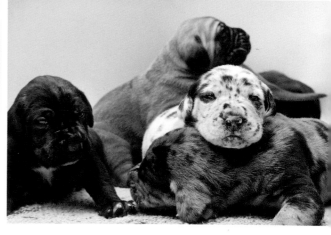

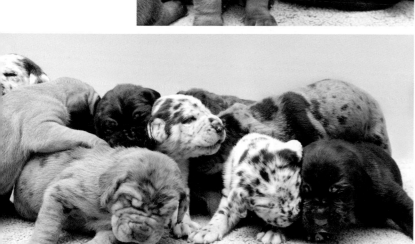

As the eyes continue to develop in the early weeks of life, a puppy's focus will become sharper and the *tapetum lucidum* will develop in most dogs. This is the layer of tissue behind the retina that aids in night vision and glows green in flash photographs!

3

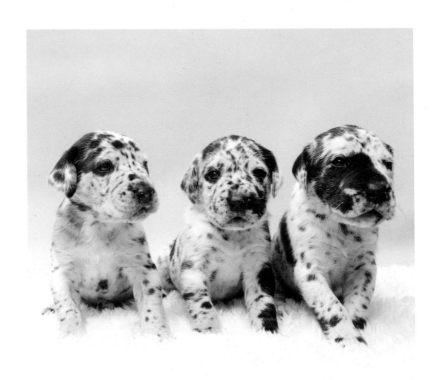

Milk to mush! The pups have entered the early phases of weaning by being introduced to mush, which is kibble soaked in puppy formula. Just like human babies, puppies have to learn how to chew! They have spent the first weeks of their lives only drinking milk; supplementing it with mush lets them learn very easy chewing while still giving them the nutrition they need. The pups are also sitting up on their own now and have begun to walk.

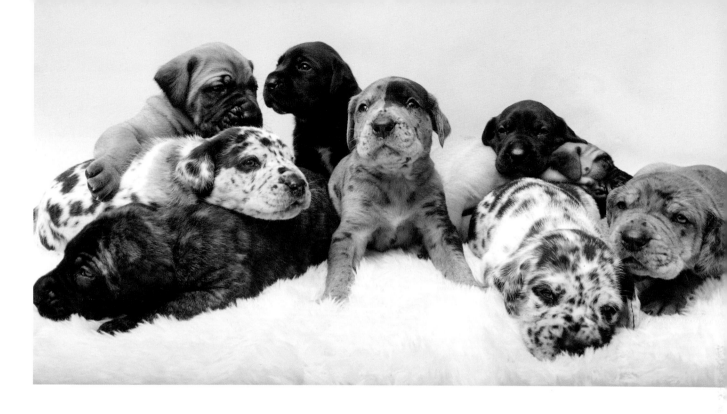

Puppies' eyes are always milky blue when they first open because the eye pigment hasn't developed yet. The "baby blue" will begin to transition to the pup's permanent color at about four to five weeks, though some the eyes of some dogs (like huskies) will remain blue throughout their lives.

4

Pups on the move! The pups are now very mobile and have become too big to sleep in the whelping box, so they have been moved out into the family's living room. Dogs instinctively do not want to poop where they sleep or eat, but if their space is too confined, they have no choice, which makes for a lot of mess and can also cause disease.

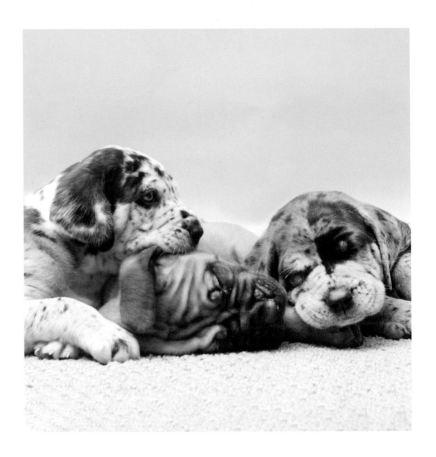

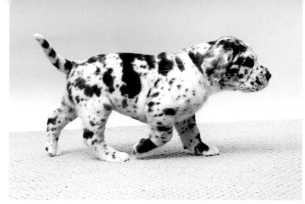

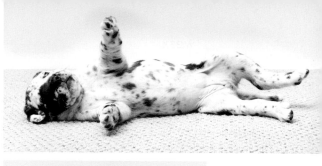

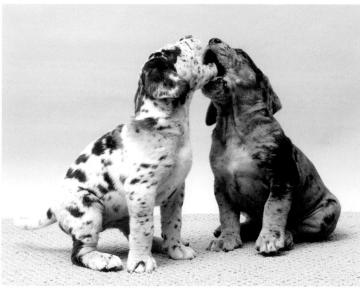

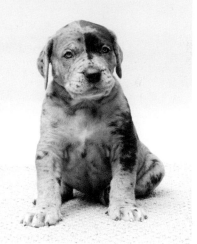

The pattern of this puppy's coat is called merle. She has very distinctive facial markings as well, which will become more pronounced as she gets older.

5

Big puppies! The Daniffs are now gaining about three pounds a week. The male is still the largest in the litter, weighing in at sixteen pounds, ten ounces. The smallest female is twelve pounds, eleven ounces, which is almost three times as much as the largest Cavalier weighed at eight weeks! The family has begun doing some basic training with the puppies—things like rewarding desirable behavior with treats and having them sit before they get their food will be the building blocks of good behavior down the road. All dogs benefit from training, but a 180-pound dog really needs to have good manners!

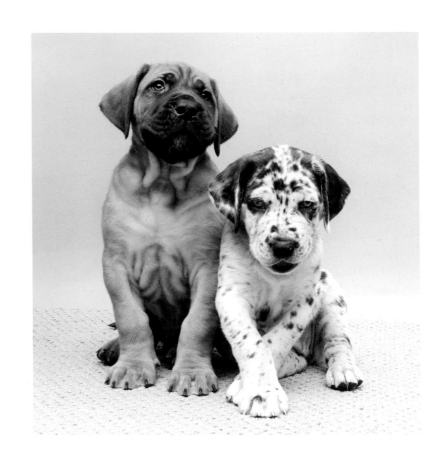

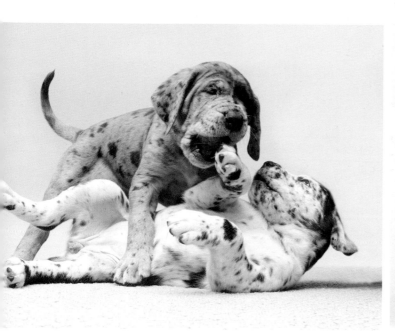

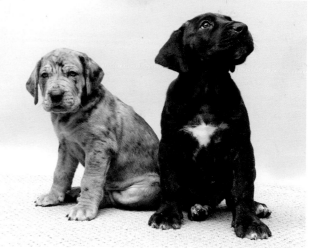

The pups are playing with each other a lot now. Just as it does for human children, play helps dogs learn social skills like how to share toys and to not play too rough.

6

Chew! Chew! Chew! For the past two weeks, the puppies' kibble has been soaked less and less as their teeth and chewing skills strengthen. Now they are eating kibble softened with pumpkin and Greek yogurt four times a day, but they are also still nursing up to four times a day because Mom doesn't want to stop! The family has also introduced puzzle feeders filled with completely dry kibble as a treat and for mental stimulation.

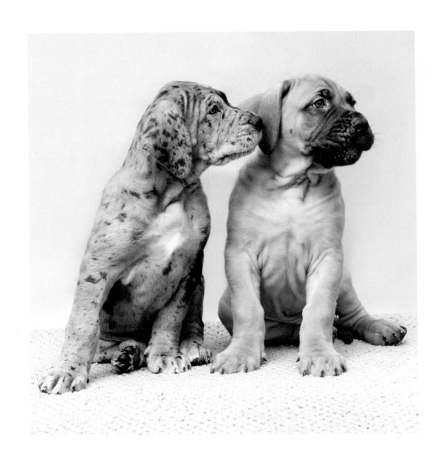

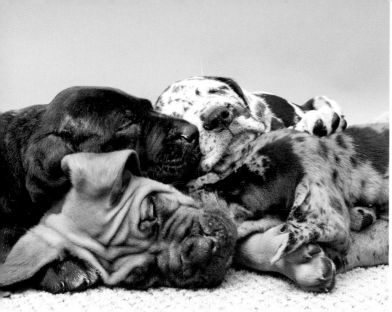

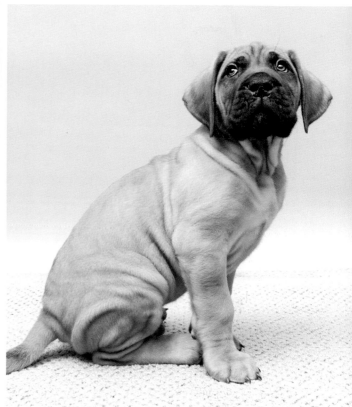

The fawn-colored male is still the largest and weighs twenty-two pounds—roughly the same as a two-year-old human toddler.

7

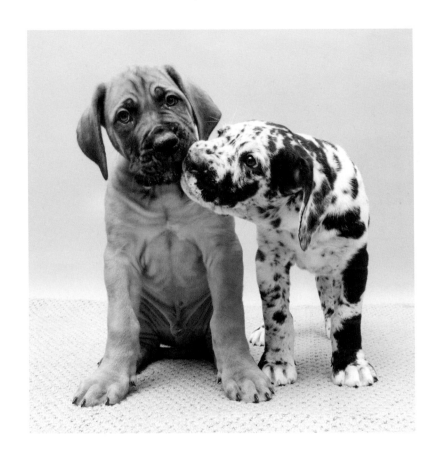

Hello, World! The puppies have now begun venturing outside the house for the first time. Going out in the yard to play has opened up a whole new world of sights and smells. They even got to have their first romp in the snow! Afterward, they were all brought inside to dry off, warm up, and snuggle together. The pups also had their first vet visit and puppy shots this week.

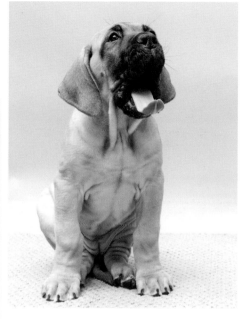

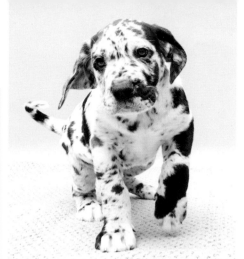

At this age, puppies are usually so fast you can barely catch them, but the Daniffs have much less energy than the other litters in this book, simply because they are so big!

8

School is in session! The puppies are being crated more often now, to teach them potty training and to ease them into crate training in their new homes. They have learned so much in their first eight weeks, and soon it will be time for their new families to take over the lead in their education. The family has stopped washing their toys so that the pups can go home with a toy that still has the scent of Mom and their siblings on it. The Daniffs are huge now. Final weigh-in has the male at thirty-one pounds and the smallest female at almost twenty-five pounds.

Despite the relatively short lifespan of giant-breed dogs (eight to ten years), the puppies actually mature more slowly than smaller breeds. The Daniffs will continue growing until they are up to eighteen months old.

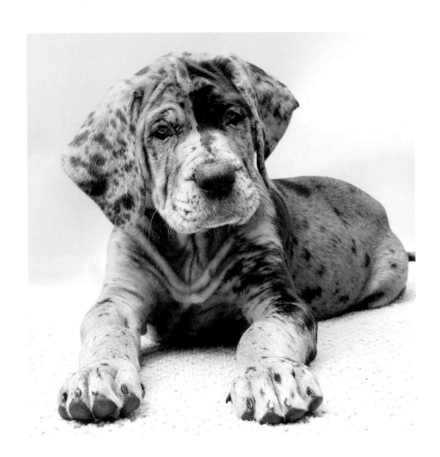

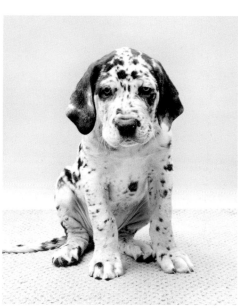
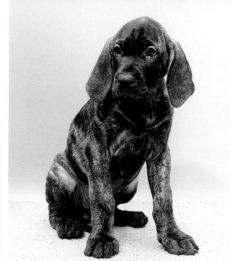
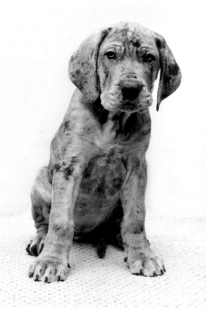
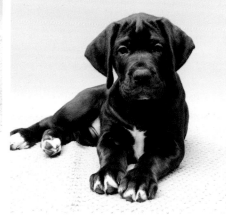

This pup is a brindlequin (harlequin with brindle markings inside some of the spots) and looks just like Dad.

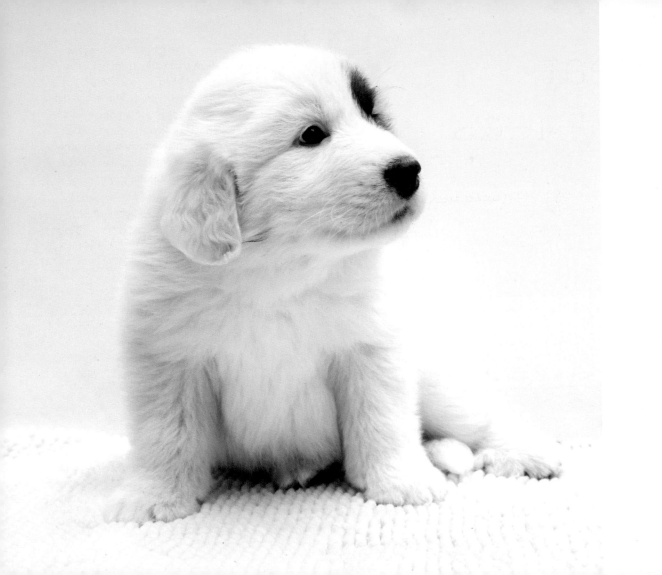

Great Pyrenees

Great Pyrenees are a breed of livestock guardian dogs that came from France, where they are called the Pyrenean Mountain Dog, or Chien de Montagne des Pyrénées. Livestock guardian dogs like the Great Pyrenees, or "Pyr" for short, protect flocks of goats, chickens, sheep, and other farm animals from predators like coyotes and bears. They are naturally gentle, loyal, and loving with people and animals they know, but can put on a fierce show for strangers and unwelcome animals. These large breed dogs can weigh up to 125 pounds when full-grown.

This litter was born on a farm in late April and was particularly small, with only three pups: two boys and one girl. Most Pyrenees litters consist of eight to ten puppies, since large-breed dogs have more space for puppies and tend to have larger litters. Both of this litter's parents work guarding flocks, but as young Pyrs mature, they sometimes show less interest in being out on the farm than in being a family companion. This breeder, who has raised many generations of Pyrs, evaluates each dog and places it into a situation that will be ideal for its unique personality. 🐾

1

Plump and healthy! The little littermates are chunky, healthy puppies weighing in at about 1.5 pounds at birth. Since there are only three of them, they are much bigger than they would have been if they had been part of a larger litter, and they will gain weight quickly without having to share their mother's milk with lots of other siblings. Unlike the English setters and other breeds who are born pure white but develop their coloring or spots as they grow, Pyrs are born with their coloring. In this litter, two have dark patches around their eyes but one is pure white and will remain so as an adult.

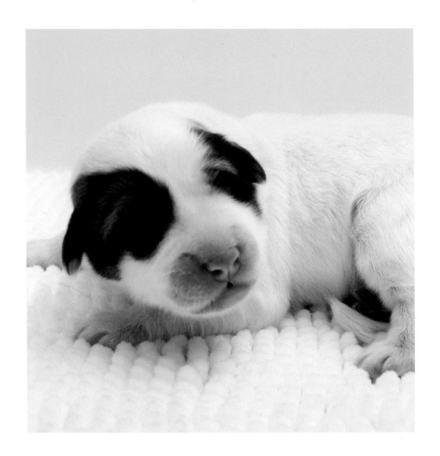

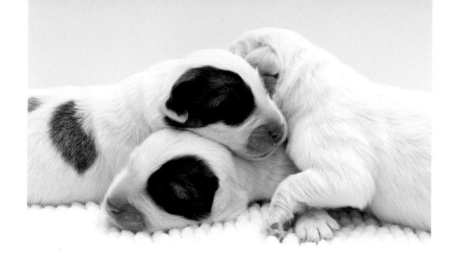

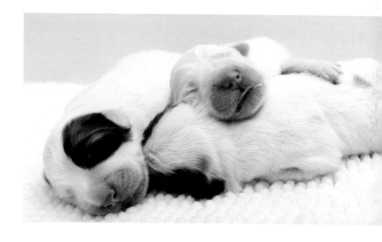

Like all dogs, Pyrs are born with their eyes and ears sealed, so they cannot see or hear for their first few weeks of life.

2

Fluffy puppies! Pyr puppies are super fluffy, with thick coats that will only get thicker as they grow. Pyrs need dense, warm fur to protect them from the elements since they live outside year-round with their flocks. Adults have a double coat that is made up of a long, coarse, water-resistant outer layer and a thick, soft, fleecy underlayer to keep them warm.

The pups' fur will transition from puppy coat to adolescent coat and then finally to adult double-layer coat at about twelve months. The puppies have doubled in weight during their first week of life!

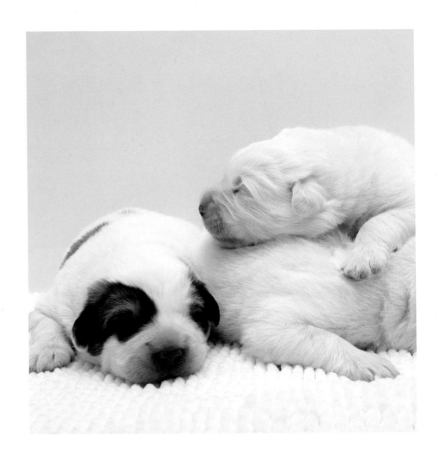

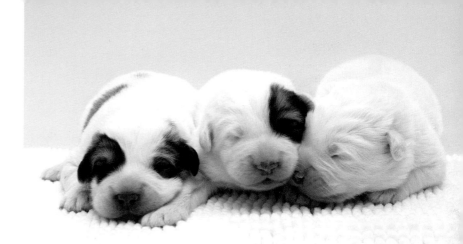

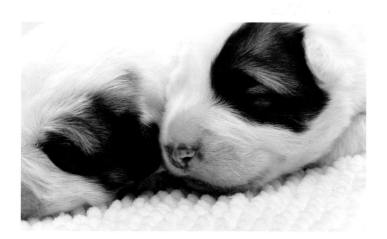

Pyrenees have black noses as adults, and the pigment has already started to come in to varying degrees on all of the pups.

3

Peekaboo! Two of the pups' eyes have just started to open, but they are not fully there yet. They have gained about twenty ounces this past week, which is a lot for a puppy! Nursing up to eight times a day and not having to compete for space or attention from Mom makes life pretty easy for this trio. The puppies have also found their voices and are starting to make little barking sounds as they crawl around the whelping box.

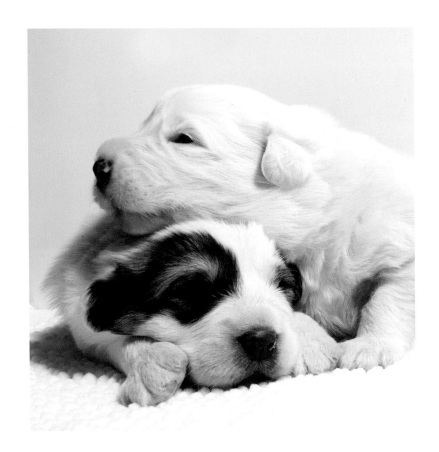

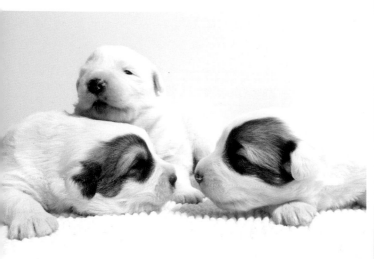

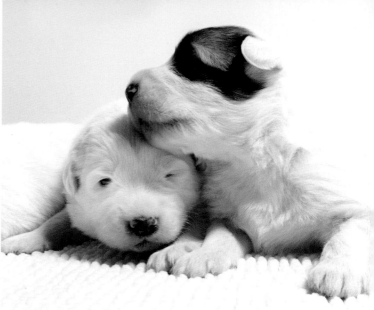

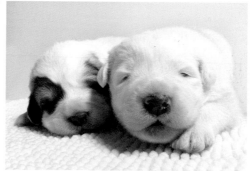

Those pink noses are almost completely
filled in now!

WEEK

4

Slow and steady! The puppies' eyes are fully open this week, and they have begun to toddle around a little, though they are still mostly crawling. They weigh more than five pounds (nearly twice as much as the Cavaliers weighed in week four), and their fluffy fur makes them look even bigger. Compare and you will see that the Pyrs are hitting milestones slower than some of our smaller breeds, which is because large-breed dogs develop more slowly than small breeds. Their bigger bones and joints need more time to develop.

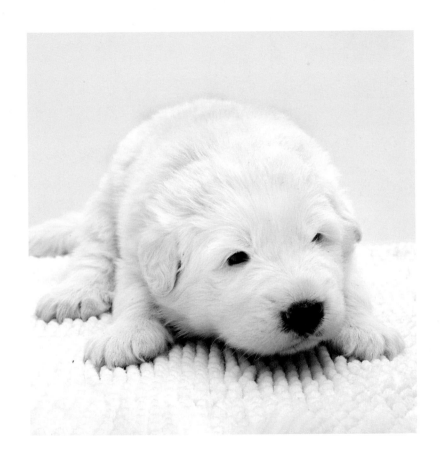

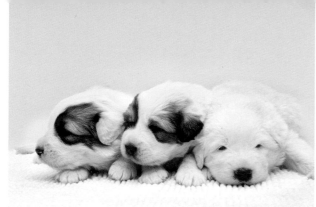

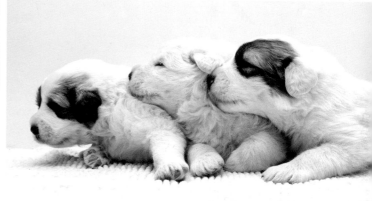

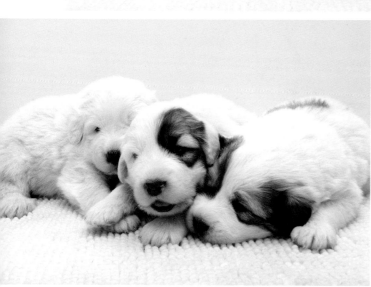

Pyrenees have two dewclaws on each hind foot. Many breeds have one rear dewclaw or, in some cases, none, but only a few breeds have two. Front dewclaws act similarly to a thumb, while rear dewclaws help provide extra traction. They are believed to be left over from when Pyrenees herded sheep over mountains. Having two dewclaws would help keep the dogs steady on snowy mountain terrain.

5

Slow and steady! The puppies' eyes are fully open this week, and they have begun to toddle around a little, though they are still mostly crawling. They weigh more than five pounds (nearly twice as much as the Cavaliers weighed in week four), and their fluffy fur makes them look even bigger. Compare and you will see that the Pyrs are hitting milestones slower than some of our smaller breeds, which is because large-breed dogs develop more slowly than small breeds. Their bigger bones and joints need more time to develop.

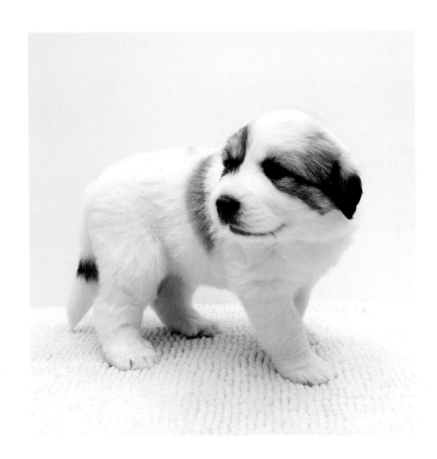

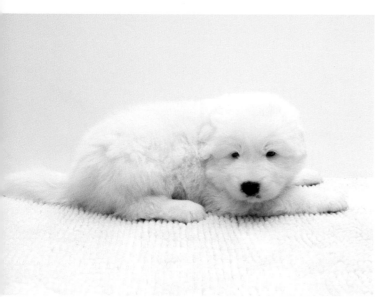

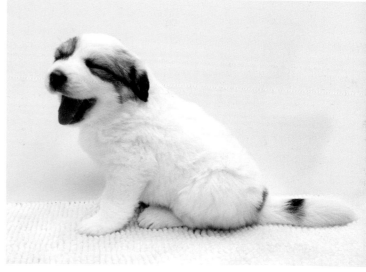

The pups are on the move!
Soon they will be running.

6

Learning to work! The puppies have joined the adult Pyrs out on the farm. They are now living outside full-time with their mom and several other adult Pyrs who guard a flock of goats. By observing the adult dogs in the pack, the pups will learn how to be effective livestock guardians so that when they go to their new homes, they will be ready to work. The three puppies are showing very different and distinct personalities.

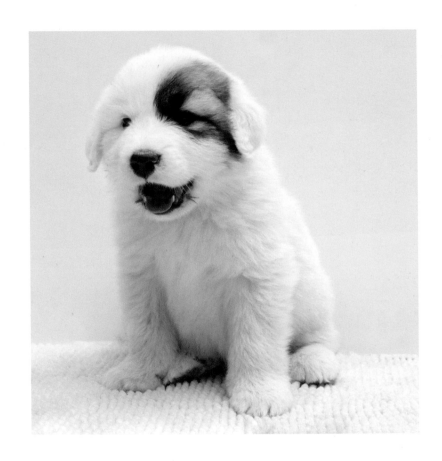

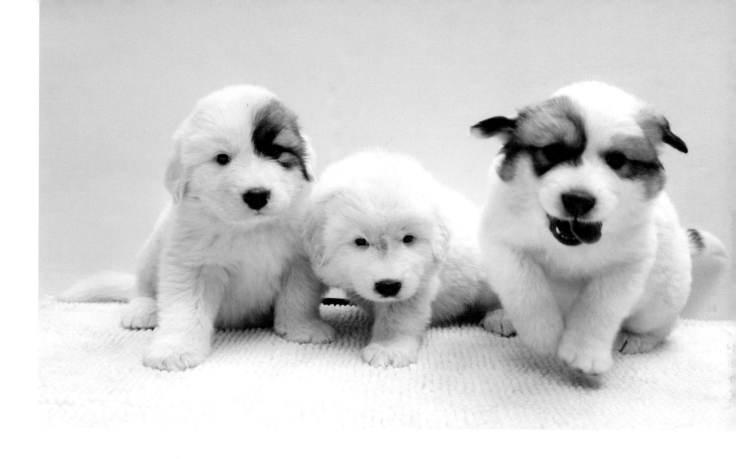

The female pup is much more active
and rambunctious than the boys.

7

Who's who? The two males enjoy being outside in the field with the goats and other Pyrs, but the female only wants to be with people. She cries and wriggles through the fencing any time someone comes near the pasture, wanting to be petted and snuggled. The breeder determines that the two boys will be working dogs and the girl will become a pet. They are now about eleven pounds but are so fluffy that they seem like they weigh much more.

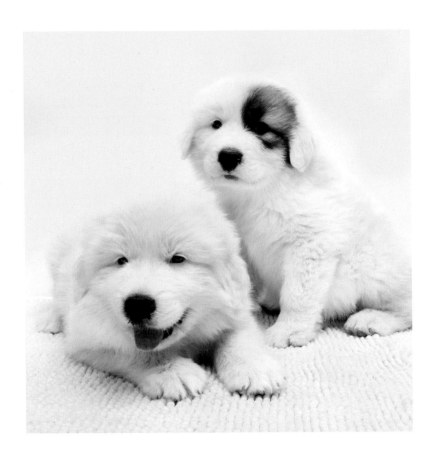

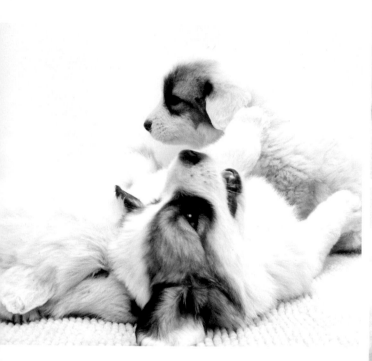

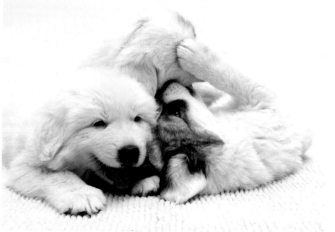

The puppies' play has become
lively and rowdy.

8

The pups will stay on the farm about four more weeks to put on more weight and continue to learn more about their job as livestock guardians. They are thirteen pounds but will be twenty to twenty-five pounds when they go home. Their herding instincts have kicked in, and they have begun to try and herd the goats. The farmer and her family decide to keep the female of the litter as a companion. She is named Ladybug after her mother, June Bug. Instead of guarding goats in the pasture, she will be an indoor dog (who gets free run of the farm), and her job will be to guard the family's small dogs.

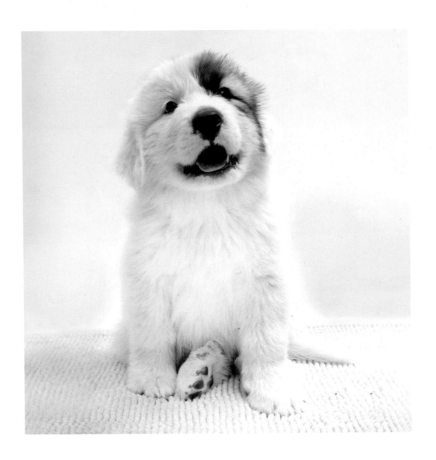

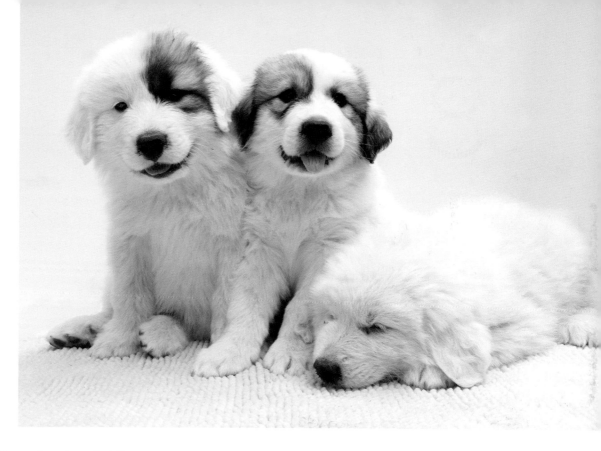

The pups now look like small versions of adult
Pyranees but will not be considered full-grown
until they are eighteen to twenty-four months.

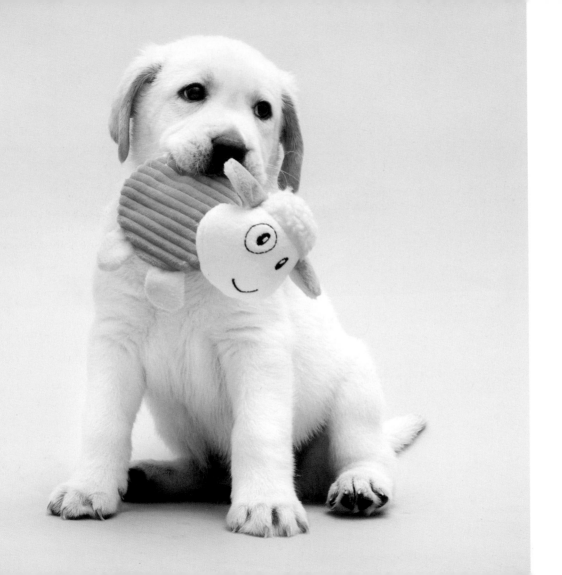

Labrador Retrievers

Labrador retrievers, or "Labs" for short, have been the most popular dog breed in America for thirty years straight, topping the American Kennel Club's list every year since 1990 and ranking in the top ten since the 1970s. Labs are intelligent, athletic, loyal, affectionate, and highly trainable, all of which contribute to their enduring popularity.

Labs belong to the sporting group and were originally bred to retrieve game, but these days they are most often seen as companions and family pets. Labs (along with the ever-popular golden retriever) are also commonly trained as service dogs or water rescue dogs.

Labradors come in three official colors: yellow, chocolate, and black, and litters can include more than one color, as we see with this litter. Here, Mom is a yellow Lab and Dad is a black Lab. This litter of five boys and three girls is a mix of yellow and black. 🐾

1

Color coded! The black puppies are solid black, but the yellow puppies have soft pink snouts, ears, and paw pads. The dark pigment will come in later. Every puppy was assigned a color-coded Velcro collar to tell them apart and keep accurate growth records. The pups were all about the same size at birth, weighing approximately one pound.

Adjusting to life outside the womb is all about staying warm and fed. Mom lives in the whelping box with the pups and is constantly nursing and cleaning them.

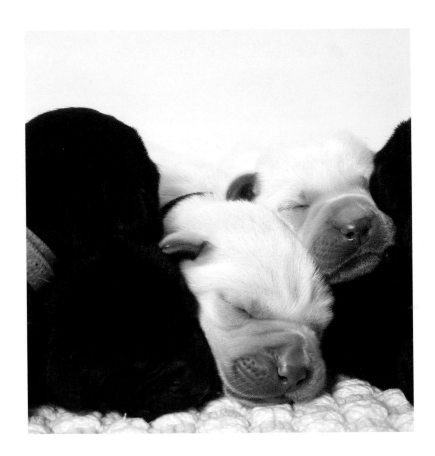

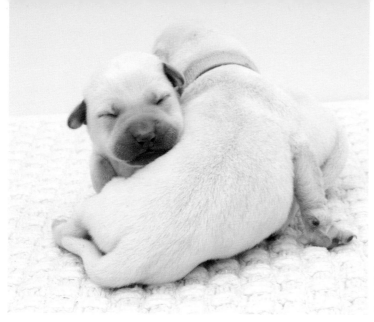

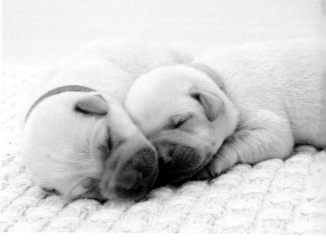

Yellow Labs are more cream colored than yellow at birth. The puppies' coat will turn yellow in the coming weeks.

2

Plump puppies! The pups' weight has doubled in their first week of life, and their bellies are all nice and round, full of Mom's nourishing milk. They still sleep almost nonstop, waking only to nurse. Although their eyes and ears are still sealed, some of them have begun to squint, indicating that the eyes will open soon.

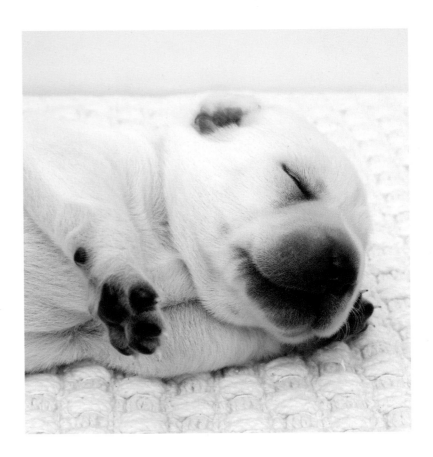

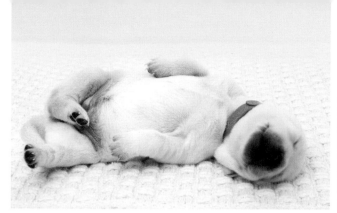

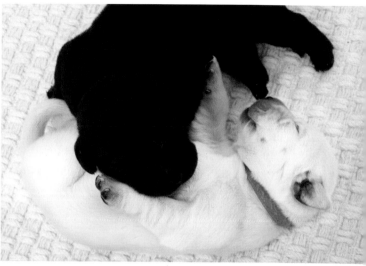

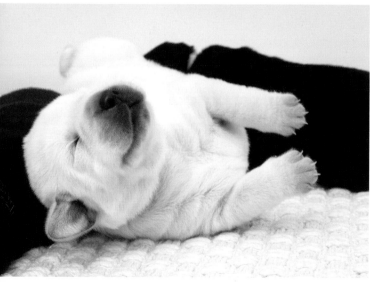

The pink ears, snouts, and paw pads have already turned to a dark brownish black, giving the puppies the beginnings of the distinctive yellow Lab coloring.

3

What's that sound? The Labs' eyes and ears are starting to open, and they are seeing and hearing the world for the first time. As puppies begin to hear, they learn to respond by barking and growling. Now the once-silent whelping box is filled with little canine voices. The puppies are also crawling a lot now, and the biggest one even succeeded in wriggling all the way out of the box.

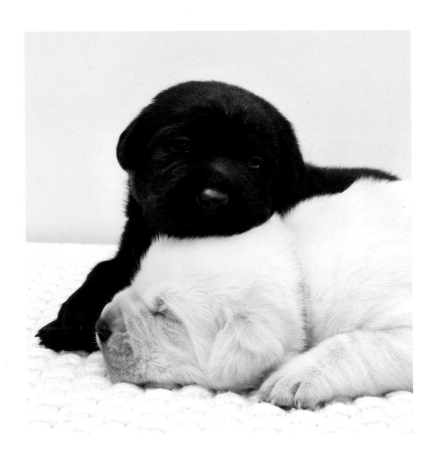

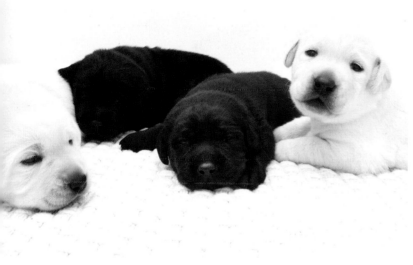

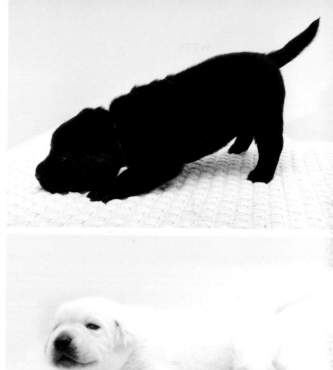

The puppies are gaining mobility quickly, starting
to stand up and to attempt to walk on their own.

4

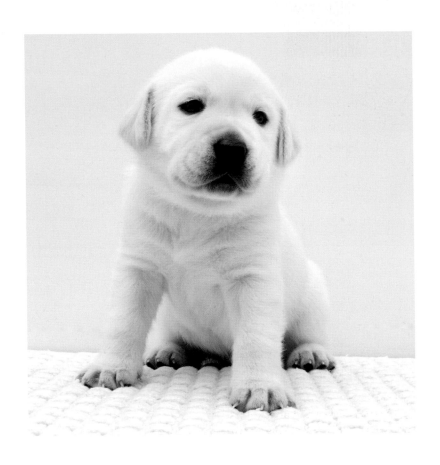

Baby teeth! The pup's baby teeth have come in, twenty-eight all together. Much like human babies, puppies are born without teeth to make nursing easier for both them and the mother. A pup's baby teeth will begin to fall out and be replaced by adult teeth at around twelve to sixteen weeks. This is when teething (and the need to chew EVERYTHING) really kicks in. The family has introduced puppy mush (kibble soaked in formula) to their diet, which is the first step toward eating solid food. The Labs are also sitting up strong now, and their eyes are wide open, even though their vision is still not sharp.

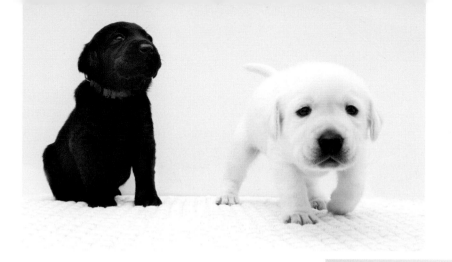

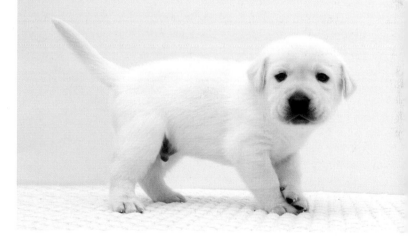

The puppies are stronger on their legs this week and can walk much better. All of them have begun to escape from the whelping box.

5

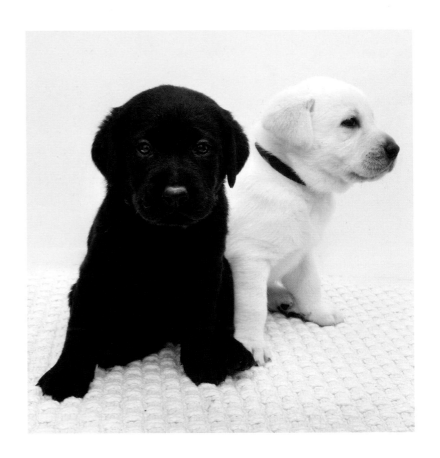

Bright and alert! The pups are transitioning from being newborns with limited senses and mobility to active, independent young dogs. They are now walking confidently, playing and tussling with each other, and learning how to be social. Though they are still nursing, it is only once or twice a day, compared to a dozen times a day as newborns!

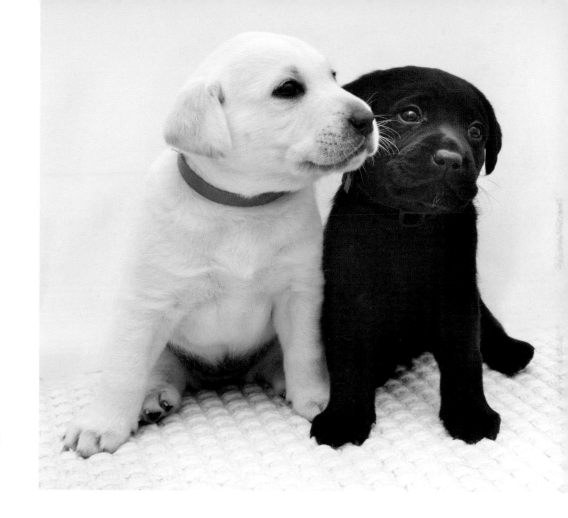

There is no "runt" in this litter, but there are normal variations in size between the largest and smallest puppies.

6

Big steps! The Labs are fully weaned this week, which means that they are eating dry kibble, drinking water on their own, and no longer nursing at all. Mom has now left the whelping box, so the pups are now sleeping and playing only with each other. They are also starting to jump, pounce, and amp up their play, becoming much more physical with each other.

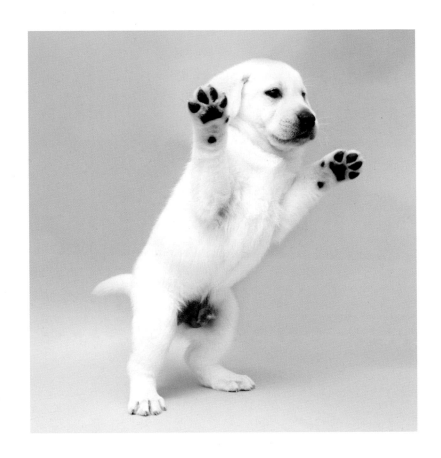

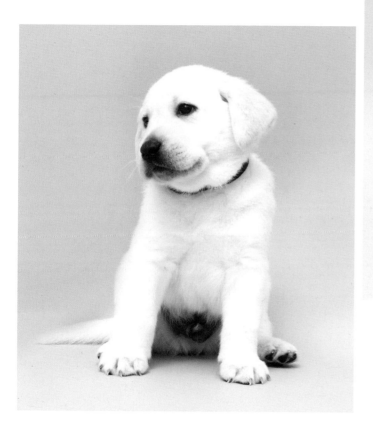

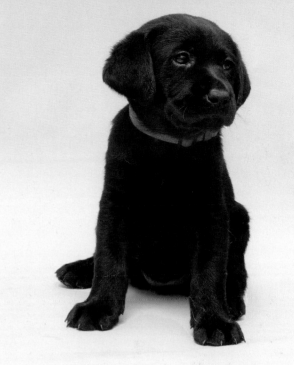

The yellow Labs' coloring is starting to darken and turn from white to more yellow, especially on the tips of their ears.

7

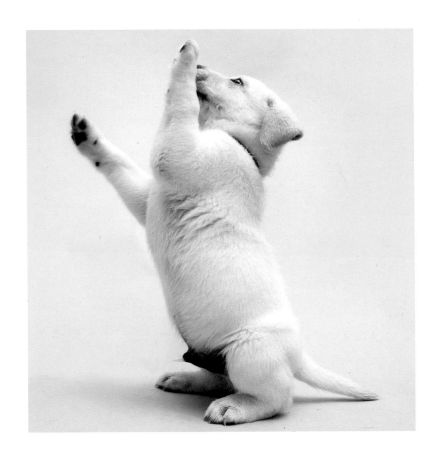

Play all day! The puppies have discovered toys and love playing tug-of-war with each other. They are tumbling around their pen (no more whelping box) and weigh an average of eight pounds. The pen is divided into two sections, one bigger and one smaller, which helps them to learn not to poop where they sleep—the first step toward being potty-trained. The pups also went to the vet this week for a wellness exam and received their first puppy shots.

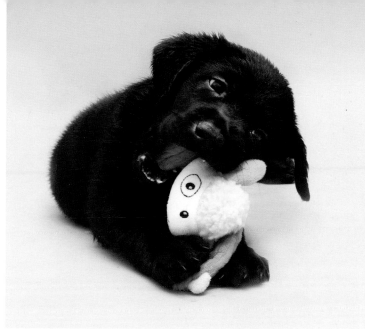

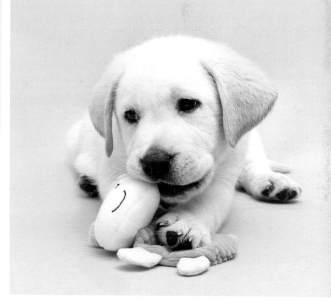

Chewing is in full force. Puppies explore the world with their mouth; that, coupled with the need to ease the pain of teething, leads them to chew on almost anything in sight. Though the intense need to chew usually stops around six months, when they are done teething, chewing is natural and fun for dogs. They do it for stimulation, to deal with anxiety, and to strengthen their jaws. It's up to us to provide appropriate things for them to chew on and to discourage destructive chewing.

8

Homeward bound! The Labs are getting ready to go to their new homes. Each new family has brought a blanket that will be rubbed on the Labs' mom and sent home with them so that they have her scent to comfort them in the transition. They now weigh between ten and thirteen pounds and are highly energetic—racing around the puppy room, shredding newspapers, and chewing anything they can get their mouths on. The developmental period from eight to twelve weeks is called the imprinting period. During this time, a puppy's brain is rapidly developing, making it an ideal time for training. Though house-training should begin now, at eight weeks puppies don't have control over their bodily functions and still have lots of accidents.

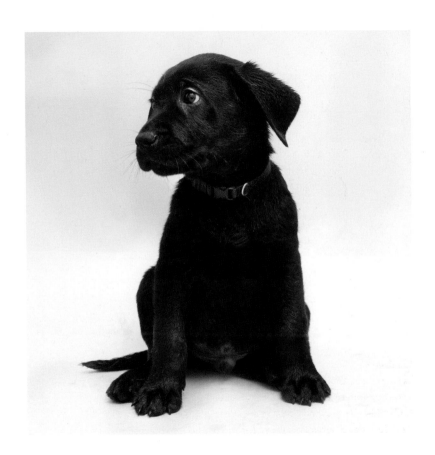

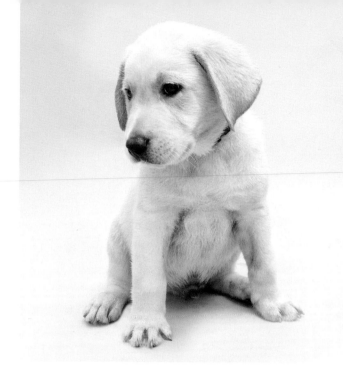

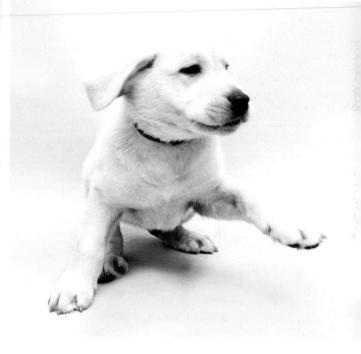

Zero to one hundred. During the imprinting period, puppies seem to have an on-and-off switch. One minute they're zooming around the yard, and the next they're crashed out for hours. Rapidly growing bodies mean tired puppies, and they will often sleep between sixteen and twenty hours at this age!

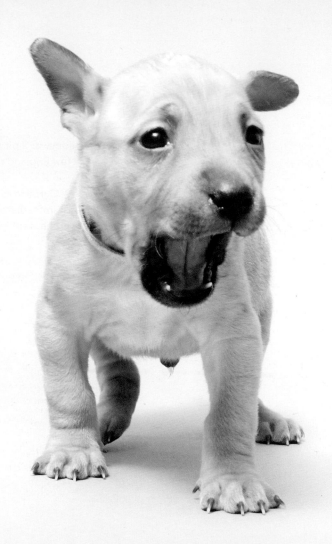

Mixed Breed

This litter's mom was a pit bull mix who arrived at a New England rescue emaciated and heavily pregnant. Amethyst had been found in South Carolina as a pregnant stray and was almost immediately sent up north as a transport. She went into labor less than twenty-four hours after she came to the shelter. The stress of the journey might have triggered her labor, or perhaps she finally felt that she was in a safe enough place to have her puppies.

Over the course of several hours, Amethyst gave birth to fourteen puppies, a huge litter for a medium-size dog. Due to the size of the litter and her state of malnutrition, many of the pups were tiny and weak: the smallest puppy weighed less than half a pound at birth. The first few days were a struggle for both the mom and the puppies, and as is often the case with large litters, several puppies didn't make it. 🐾

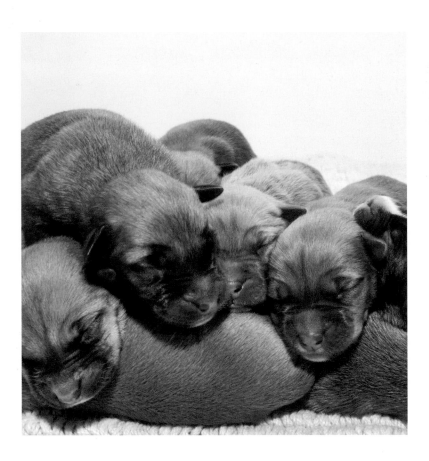

Getting to know you! As is the case with most shelter litters, very little was known about these puppies prior to their birth. No one knows who the father was, but Mom is beige with a black snout, and the puppies are a mix of beige-and-white, fawn, brindle, and black brindle. Sometimes litters can have multiple fathers, and that may be the case here.

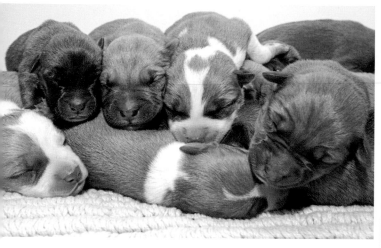

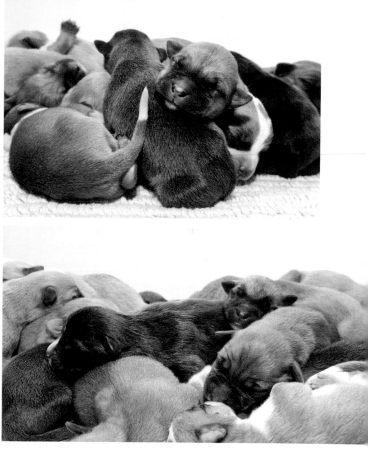

Despite the different coats and colors, all the pups were born with pigmentless pink noses.

2

Clean and cozy! The puppies are staying cozy with Mom, who feeds and cleans them as many as a dozen times a day. For the first few weeks of life, puppies' digestive systems are still developing, which means they cannot pee or poop on their own, so Mom has to lick them every few hours to stimulate them to go! The pups are headed to a foster home where they can receive more individualized care. Most shelters prefer for moms and puppies to be in a foster home for the first eight weeks, but it's a lot of work raising a litter, so a foster home is not always available.

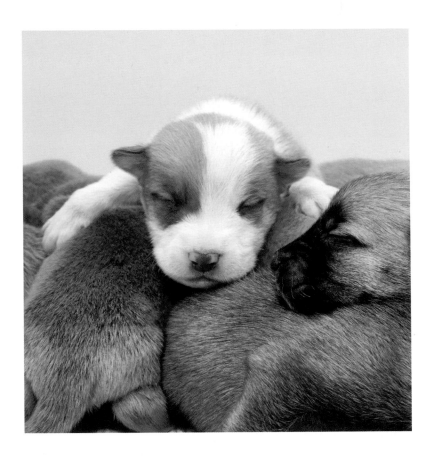

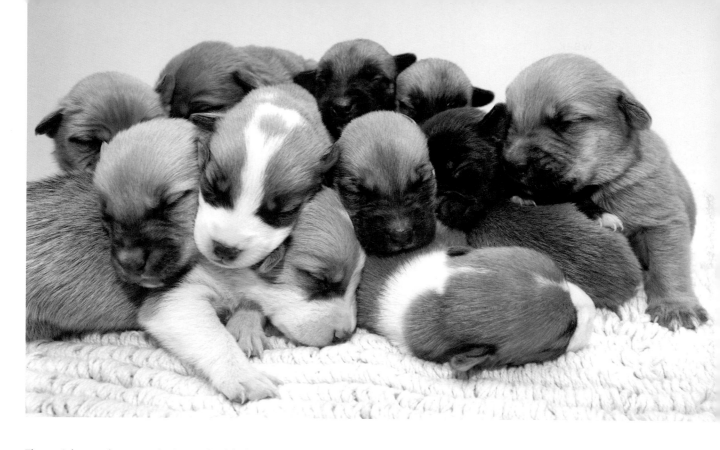

Those pink noses have mostly changed to black, but a few pups still have a mix of pink and black as the pigment floods in.

3

A bump in the road! The puppies contracted an upper respiratory infection, which is common among shelter animals and is highly contagious. Out of caution, the foster family, which has several other dogs, returned them to the rescue. The pups are now on medication but are coughing and feeling a bit lethargic. Mom is struggling to produce enough milk for so many puppies, so they have to be supplemented with formula and mush.

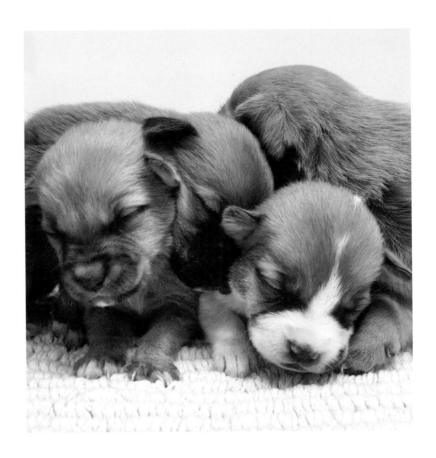

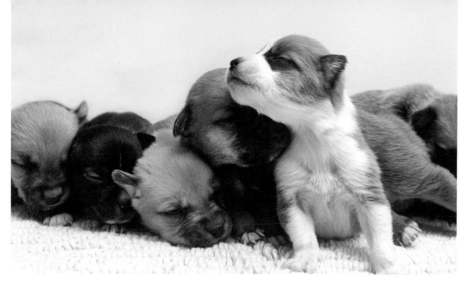

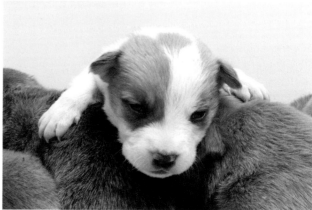

The pups' eyes are squinty and starting to open.

4

New beginnings! The pups are now in a new foster home with one of the shelter employees, where they will stay for the next few weeks. They have a nice, warm pen and are recovering from the upper respiratory illness, though many are still coughing. Their eyes are open now, and they are barking and growling.

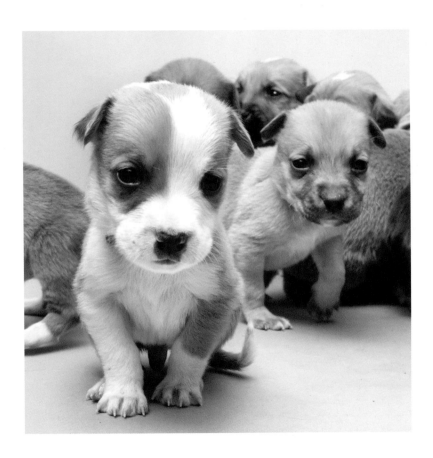

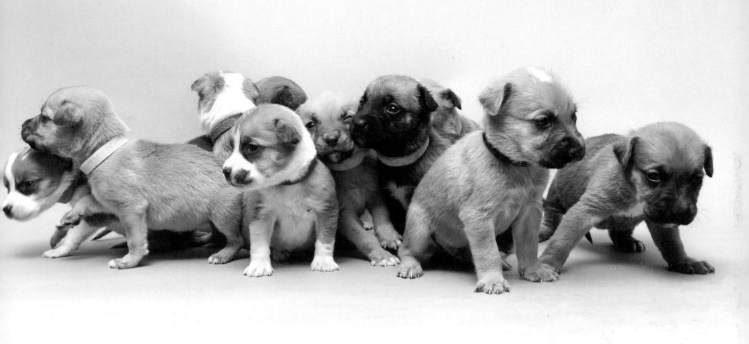

You can really see the diversity within the litter.
The little white splotches on some of the pups'
heads indicate who needs medicine.

WEEK

5

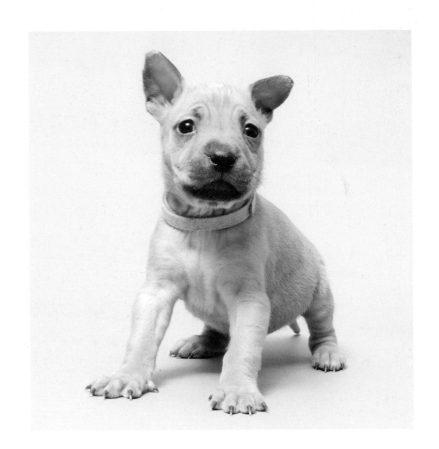

Eyes wide open! The pups' eyesight is mostly developed now, which means that they will begin to form relationships with each other and with humans. In the first few weeks, their only real bond is with Mom, but now the world is full of potential friends like the new teddy bear that they love to snuggle with.

Mixed Breed 112

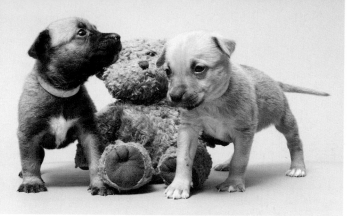

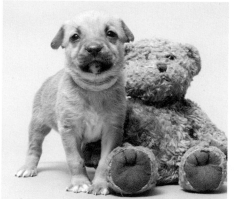

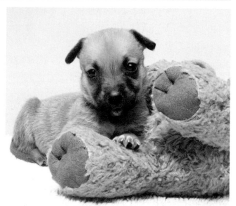

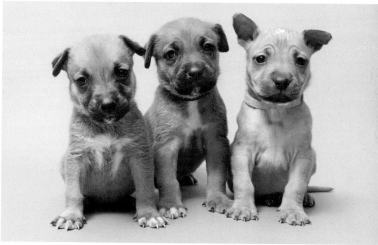

The ears on one of the puppies have started standing up rather than flopping over. Will they stay like that? Wait and see.

6

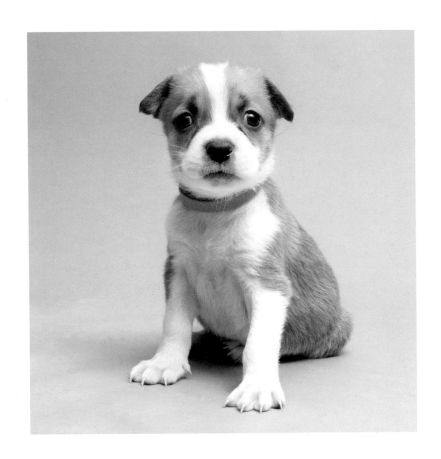

Let me introduce myself! The puppies' personalities are beginning to emerge. Whether brave and bold or quiet and shy, these traits will help shelter workers match the pups with the right adopter down the road. This week the puppies are also strong on their legs and have begun to run and jump. They are still sleeping in a pen with Mom and are occasionally nursing but are almost fully weaned.

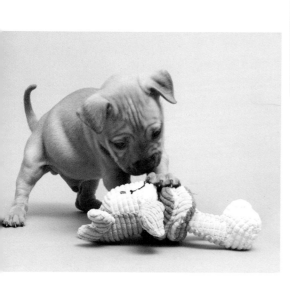

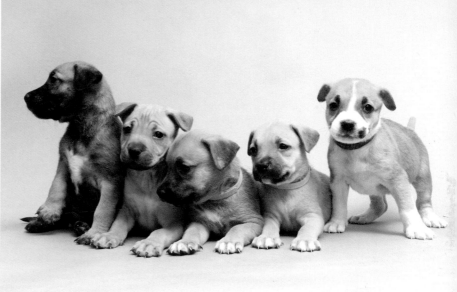

The pups are becoming amore energetic
every day, and they love playing with toys!

WEEK

7

Party animals! Back at the shelter, the puppies are being exposed to lots of new people, sounds, and smells to ease their fears later. Puppies experience their first "fear period" between eight and eleven weeks. This is a time of cognitive change, when they suddenly seem afraid of everyday things and people and get easily spooked. So prior to that, between six and eight weeks, it's important to safely expose them to as many people and situations as possible.

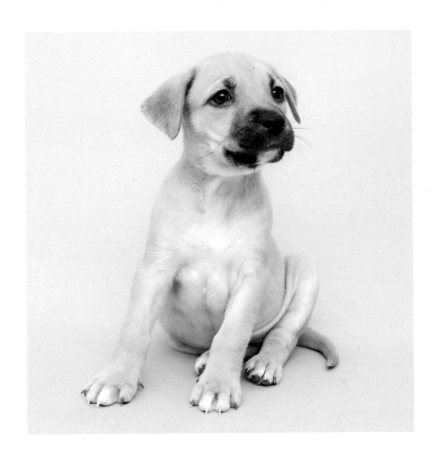

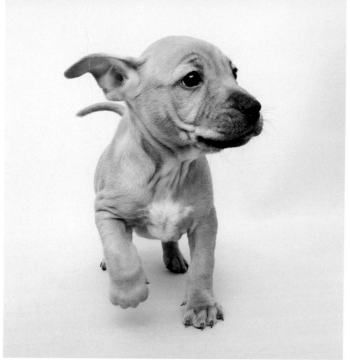

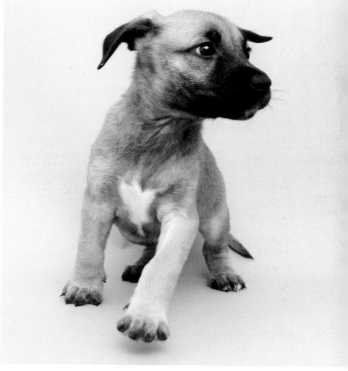

The puppies are full of energy, running, playing, and wrestling with each other.

8

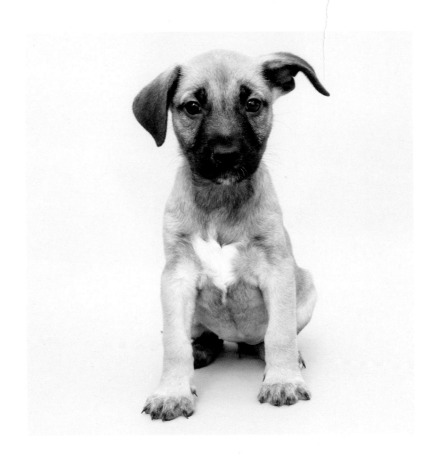

Muttastic! Their mix may be a mystery, but these pups are 100 percent adorable. Typically, at eight weeks puppies go to their new homes, but this litter will stay at the shelter for several more weeks until they are a bit bigger and other puppies have been placed. Mom has been spayed and will also go up for adoption.

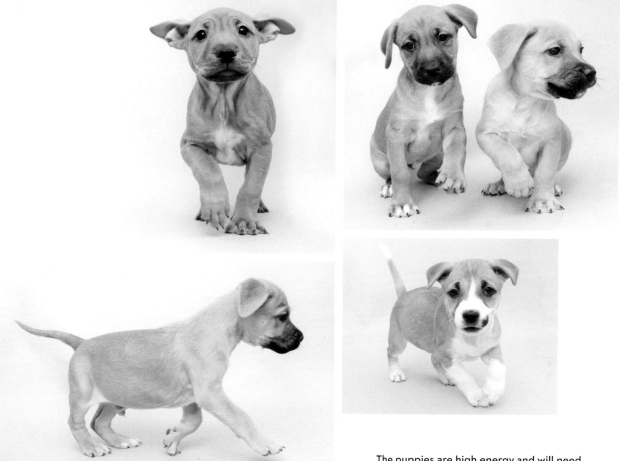

The puppies are high energy and will need lots of daily exercise in their new homes.

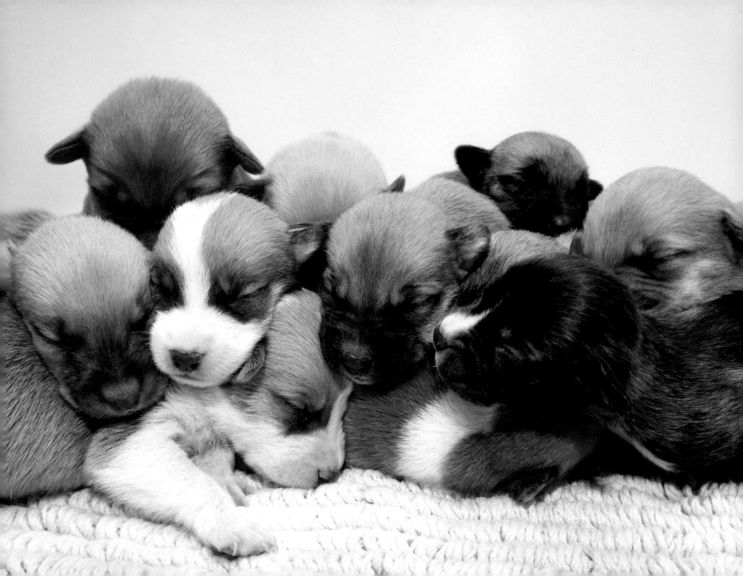

About Puppies

Bringing new life into the world, whether human or canine, must be done deliberately and with purpose. Regardless of any other considerations, the love of dogs and the love of the breed must be the driving force. I believe that when we breed an animal, we enter a sacred trust, and it should always be done with great care and as much knowledge as we can gather. Breeding solely for profit is exploitation, pure and simple. Breeding without expert knowledge, experience, or mentors is ignorant and inhumane. Shelters are full of dogs that were the unwanted result of accidental or backyard breeding.

Raising a litter of puppies requires a herculean amount of work that consists of sleepless nights and long days of constant, never-ending cleaning. For those who are up to the task, there are almost always rescues looking for loving foster homes to care for new moms and their pups. For those who think they might want their own dog to have puppies, see paragraph one.

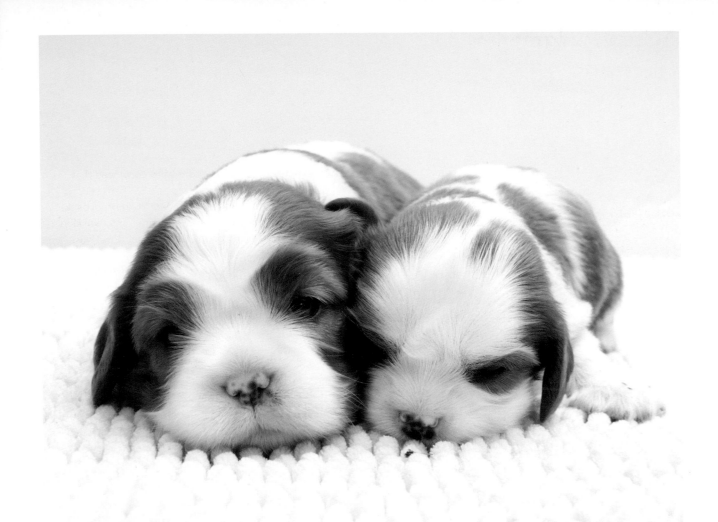

Acknowledgments

After seventeen years, I am thoroughly convinced that nothing in my life is possible without my friend, mentor, sometimes therapist, and always agent Joan Brookbank, without whom I am fairly sure I would break into a million pieces. Fate was smiling on me the day I sat down with you all those years ago.

I am immensely grateful to the families who let me follow their precious puppies from day one during a pandemic. I was invasive and relentless, and yet you put up with me. To Anne Petersen, Michaela Masi, Laura Benedetti, Jocelyn Dame, thank you! Also, to Karen Kalunian and Tammy Gallo at East Greenwich Animal Protection League for making time for me even though there is never enough time or enough hands in rescue.

So much love and gratitude to my Princeton Architectural family: Jennifer Thompson and Sara Stemen who are endlessly supportive, patient, and enthusiastic. Also, to Paula Baver and Paul Wagner for the stunning *Puppy Life* design. This material really needed the right format and you nailed it.

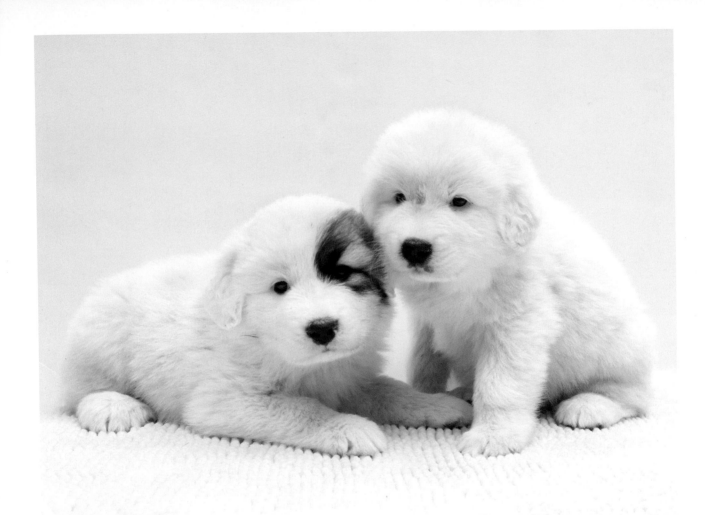

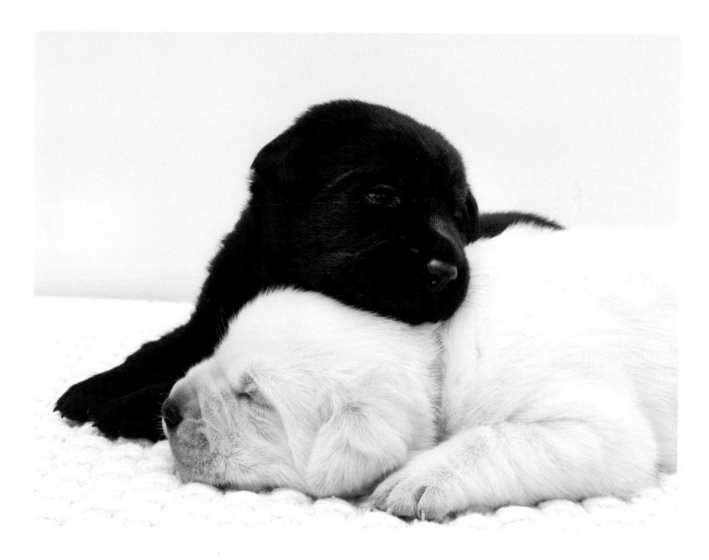

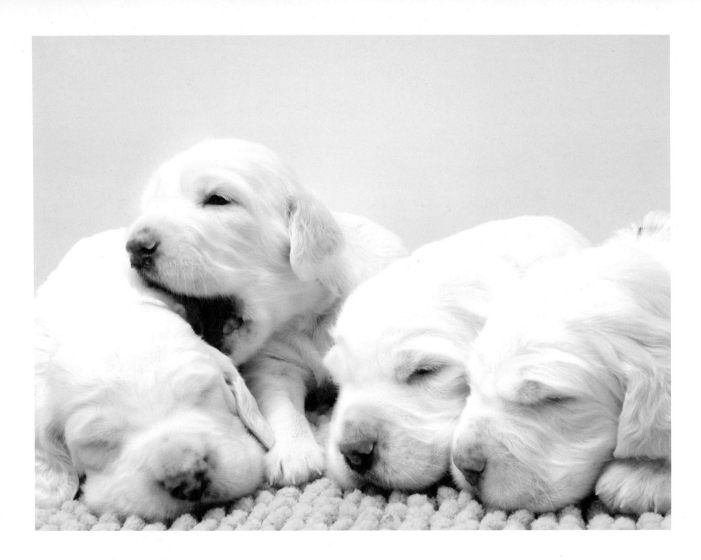

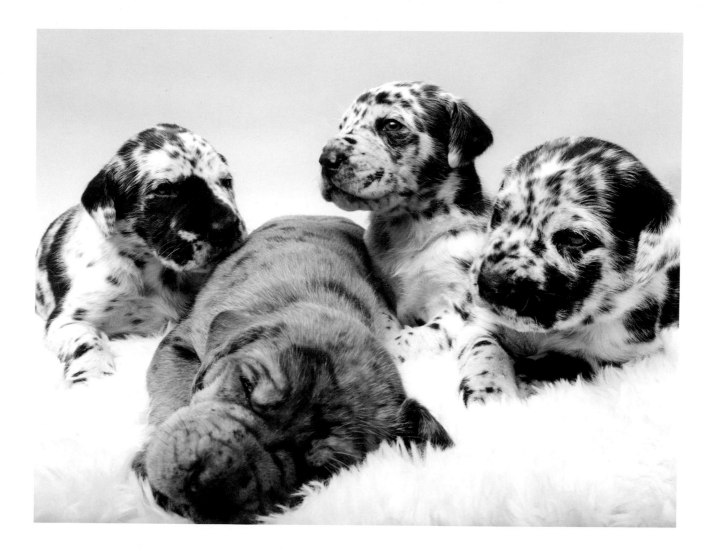

Published by
Princeton Architectural Press
70 West 36th Street
New York, NY 10018
www.papress.com

Editors: Jennifer Thompson and Sara Stemen
Designer: Paula Baver

Library of Congress Cataloging-in-Publication Data
Names: Scott, Traer, author.
Title: Puppy life: the first eight weeks of bonding, playing, and growing / Traer Scott.
Other titles: First eight weeks of bonding, playing, and growing
Description: New York, NY: Princeton Architectural Press, [2022] |
Summary: "Six puppy litters of various breeds are followed through week-by-week stages of puppy development
from birth through 8 weeks, in full-color photographs and informative descriptions" —Provided by publisher.
Identifiers: LCCN 2022006833 | ISBN 9781648961304 (hardcover) |
ISBN 9781648961977 (ebook)
Subjects: LCSH: Puppies—Pictorial works. | Puppies—Photographs.
Classification: LCC SF430.S385 2022 | DDC 636.70022/2—dc23/eng/20220224
LC record available at https://lccn.loc.gov/2022006833